Interpassivity

The Aesthetics of Delegated Enjoyment

Robert Pfaller

T0322415

EDINBURGH
University Press

Edinburgh University Press is one of the leading university presses in the UK. We publish academic books and journals in our selected subject areas across the humanities and social sciences, combining cutting-edge scholarship with high editorial and production values to produce academic works of lasting importance. For more information visit our website: edinburghuniversitypress.com

Edinburgh University Press Ltd
The Tun – Holyrood Road, 12(2f) Jackson's Entry, Edinburgh EH8 8PJ

Typeset in Bembo
by R. J. Footring Ltd, Derby, UK, and

Printed and bound by CPI Group (UK) Ltd, Croydon, CR0 4YY

A CIP record for this book is available from the British Library

ISBN 978 1 4744 2292 5 (hardback)
ISBN 978 1 4744 2294 9 (webready PDF)
ISBN 978 1 4744 2293 2 (paperback)
ISBN 978 1 4744 2295 6 (epub)

Contents

Acknowledgements

Introduction: Interpassivity Today – an earlier version of this text was published in German in Robert Pfaller, *Ästhetik der Interpassvität*, Hamburg: philo fine arts, 2008. Translated from German by Lisa Rosenblatt.

1 The Work of Art that Observes Itself: The Aesthetics of Inter-passivity – first published in Italian in *Agalma. Rivista di studi culturali e di estetica* 7–8 (March 2004): 62–74.

2 The Parasites of Parricide. Living through the Other when Killing the Father: Interpassivity in *The Brothers Karamazov* – talk given at the dance performance, *Brothers Karamazov – volume 1*, directed by Mateja Bucar, Ljubljana, Slovenia, 20–2 December 2006; festival Fabbrica Europa, Florence, Italy, 8–9 May 2007, cf. http://www.dum-club.si/mateja/karamazov1/karamazov1.htm (last accessed 11 November 2016). Earlier version published in German in Robert Pfaller, *Ästhetik der Interpassvität*, Hamburg: philo fine arts, 2008, 130–5.

3 Little Gestures of Disappearance: Interpassivity and the Theory of Ritual – published in English in *Journal of European Psycho-*

analysis, Humanities, Philosophy, Psychotherapies 16 (Winter–Spring 2003/4): 3–16.

4 Interpassivity and Misdemeanours: The Art of Thinking in Examples and the Žižekian Toolbox – first presented at the annual meeting of the British Society of Phenomenology, St Hilda's College, Oxford, 7 April 2006. Published in English (and Chinese) in *International Journal of Žižek Studies* 1.1, special issue *Why Žižek?* (2007): 30–50. Translated from German by Astrid Hager.

5 Against Participation – published in German and English in Susanne Jakob (ed.), *Risiko Curating & weitere Projekte. Zwischen Intervention und Partizipation*, Stuttgart: Kunstverein Neuhausen, 2007, 37–49 (exhibition catalogue). Translated from German by Rebecca van Dyck.

6 Matters of Generosity: On Art and Love – published in Slovenian and English in *maska* XXVII.147–8 (2012): 124–33 (Slovene cultural journal).

7 What Reveals the Taste of the City: The Ethics of Urbanity – published in English in *Urbanity. The Discrete Symptoms of Privatization and the Loss of Urbanity*, ed. content.associates, Vienna: content.associates, 2013, 30–46 (conference report). Translated from German by Eric Scott.

Incitements

Visit the series web page at: edinburghuniversitypress.com/series/incite

Introduction: Interpassivity Today

<div style="text-align: center">

1

</div>

Interpassivity is a widespread, and yet mostly unacknowledged, form of cultural behaviour. Rather than letting others (other people, animals, machines, etc.) *work* in your place, interpassive behaviour entails letting others *consume* in your place. We can speak of interpassivity when people, for instance, insist that others drink their beer for them, or when they let recording devices watch TV programmes in their place, or when they print out texts instead of reading them, or when they use ritual machines that pray or believe for them vicariously ('ora pro nobis'), or are happy that certain TV shows feature canned laughter that displays amusement in their place. Clearly, not all of these multiple social practices and individual behaviours are *necessarily* interpassive. However, I would claim that without a concept of interpassivity, many of these practices and behaviours cannot be sufficiently explained. Without the concept of inter-passivity, we cannot grasp the ways in which these practices are grounded in the preference of particular subjects for *delegating their enjoyment* rather than having it themselves.

Rather than delegating, for instance, their responsibilities to representative agents, interpassive people delegate precisely those things that they *enjoy* doing – those things that they do for pleasure, out of passion or conviction. Rather than letting others *work* for them, they let them *enjoy* for them. In other words, they delegate *passivity* to others rather than *activity* (as is the case, for example, in practices of interactivity, and also in the social division of labour and class division).

2

This concept of interpassivity, which I proposed in 1996,[1] originally fulfilled a primarily critical function for media and theory. My intention back then was to relativise and water down the overwhelming dominance at the time of the discourse of interactivity. The concept was mainly intended for artists, who were responding in complete panic to the pressures of interactivity, obsessively pondering about how to and whether they could include the audience in their work. The idea of a 'negative magnitude' (Kant 1977b) of interactivity was meant to create a space of distance that would enable a more detached observation.

However, this original opponent has now largely vanished into thin air. The interactivity hype is over and we are left amazed that the euphoric texts on the theme had such a vast audience of believers. Of course, some now fix their hopes with the same intensity and self-evidence on other, very similar myths – for example, participation. However, the theory of interpassivity was never so tightly bound up with its opponent that it would have to go down with it. The notions of interpassivity and

interactivity differ fundamentally in their discursive function: they were two entirely different language games. The discourse of interactivity, facilitated mainly by new media, was a revival of very old wishes and utopias,[2] which had become unquestioned facts – consequently, this discourse was more of an ideology than a theory. Contrary to this, the thinking of interpassivity consisted of a series of disturbing observations, questions and considerations, regarding which initially no one – not even those who advanced them – knew where they would lead. It is precisely this uncertainty and openness that distinguishes a theory from an ideology.

3

However, right from the outset the term 'interpassivity' functioned as a shibboleth: as a mark of philosophical partisanship (as all openness relies on previous constructive decisions). It was similar to what Étienne Balibar once remarked with regard to Louis Althusser's name: you simply uttered the name and you noticed that you had friends (Balibar 1991: 119). Philosophers such as, first and foremost, Slavoj Žižek, Mladen Dolar and Henry Krips[3] recognised that this concept opened up a theoretical perspective. And so they embarked upon the adventure and developed research of their own related to the questions associated with interpassivity. Psychoanalysts, media theorists, curators, art theorists and later many others – from areas such as dance, theatre, film and literature studies, political theory, law studies, cultural anthropology, theology and medieval studies – soon followed.[4] Yet not only theorists but also artists responded strongly to the concept. Brilliant works in fine arts[5] as

well as notorious theatre productions, for example by directors René Pollesch and Christoph Schlingensief, drew inspiration from the concept and developed it in particular, unanticipated directions.[6]

The philosophical common ground consisted in a position related to Althusser's philosophy – namely, deep mistrust of the assumption that 'activity' is fundamentally good and that, consequently, activating the beholder will always be aesthetically productive and politically satisfying. Yet, if we take seriously Althusser's idea that becoming a subject is one of the key mechanisms of ideological subjugation (see Althusser 1971), then becoming an *active subject* cannot be turned into any universal political solution. Thinking about interpassivity therefore means no less than investigating a basic, unquestioned assumption of most emancipatory movements since 1968, namely the assumption that active is better than passive, subjective better than objective, own better than foreign, changeable better than permanent, immaterial better than material, constructed better than essential, and so on. In other words, it means questioning the theoretical humanist paradigm of 'reappropriation' that has been so precisely described by Gianni Vattimo (see Vattimo 1991: 28ff.) and, following Althusser, also subjected to well-founded critique by more recent psychoanalytical theory (see Grunberger and Dessuant 1997). This paradigm has shaped neo-Marxism, with its critique of 'reification' and 'alienation', as much as feminism with its critique of the 'object' status of women, or the theory of 'immaterial labour' popular in recent years.

The 'theoretical anti-humanism' of the concept of inter-passivity has from the very beginning united all who have been interested in this perspective. As a result of this, though not exclusively so, the *theory* of interpassivity was enthusiastically received.

4

And so, just as Althusser was a *theoretical anti-humanist*, we were *theoretical interpassivists*. However, the question of whether one should also feel sympathy with the *practices* of interpassivity or not was a wholly different and open matter at that time.

4

The peculiar relation of interpassivity to pleasure was one of the initial questions that the theory had to grapple with, that is, the question of why interpassive people seemed to avoid their desire and to transfer it instead to other people, animals, machines and so on. The question was: what did they gain from this? Why was it that some people did not want to watch television themselves, contemplate art, laugh, cook or make love, and instead preferred to have these things taken care of by other agents in their place? And moreover, why couldn't they simply do without these things altogether?

In addition to the fundamental aesthetic or libido-economical paradox of favouring the delegation of a pleasure over one's own pleasure, the question of the relationship between interpassive people and their delegates also arose: was it a matter of identification? Love? Amplified narcissism? Or was it necessary to conceive of a new type of relationship here?[7]

5

Initially, the problem of how interpassivists came to be certain that it was *their* enjoyment that was being represented by a person or a device seemed to be a secondary matter. And yet

the question of how they could be so sure that their guest drank beer *for them*, and not for someone else, soon divulged the rich potential of cultural-theoretical consequences hidden within this inconspicuous phenomenon. In this manner it was revealed that interpassive behaviour is always necessarily connected with a seemingly miniature staging of the act of enjoyment. With the help of the photocopier, intellectuals played at reading in libraries. Only those who caused the staging could feel represented. Akin to the substitute behaviours of compulsive neuroses decoded by Freud (see Freud [1907]), in these cases, too, the figurativeness of the interpassive substitute actions was often barely noticeable; as a rule the actors were not aware of them. And even if they had thought of this, they would never have themselves believed it. After all, who would ever be capable of confusing the operation of a photocopier with the act of reading and take it to be its fully fledged equivalent?

At this point it became obvious that we were dealing with illusions of a special sort: not merely illusions that *certain people* have never believed in, but apparently illusions that *no one* has ever believed in. These illusions appeared entirely unsuitable for anyone ever to believe in. And yet a good deal of everyday cultural behaviour and individual pleasure gains which emerged from them could only be described in this way. Only thanks to these 'unbelievable' illusions and to their presence in the situation could the intellectuals leave the libraries thoroughly satisfied with their prey, even when they would perhaps never look at the copies again. We had to begin reconstructing these illusions and clarifying whom they were actually meant to convince. The process of reconstruction of 'illusions without owners' or 'illusions of the others' resulted in a series of un-anticipated discoveries – ultimately, of a new psychic observing

agency, only touched upon to date by psychoanalytical theory, but not yet conceptually registered: that of the 'naive observer' (Pfaller 2014).

6

Interpassivity's double delegation – the fact that interpassive people first transfer their *pleasure* to a representative agent, and secondly transfer the *belief* in the illusion they have staged to an undefined, naive other – provided a valuable clue for a further discovery. Not only did the actions that interpassive people used to back up their delegation take the form of rituals (similar to the 'ceremonial behaviours' of neurotics analysed by Freud [1907]), but the reverse was also true. All rituals had from now on to be considered as interpassive behaviours. Far from deriving from some external malicious suspicion towards religious, state or other types of ceremonial acts, it was precisely these ideas that made it possible to explain the often amazing hostility of some religions towards their own rituals at particular times (see Humphrey and Laidlaw 1994: 1). What religions fought within their own rituals was precisely their interpassive function. The theory of interpassivity has at this point presented us with an unanticipated benefit in terms of a solution to a fundamental problem of cultural theory (on this, see Pfaller 2008).

7

One thing has become clear by now. In interpassive behaviour, people take up selective contact with a thing in order, in exchange,

to entirely escape that very thing – and indeed, not only, as we have established to begin with, with regard to enjoyment, but also with regard to belief; that is, with regard to an identification with an illusion. Interpassivity is thus a strategy of escaping identification and consequently subjectivisation. Precisely there, where it is suggested that they become self-conscious subjects (through 'interpellation' in the sense of Althusser [1971]), people seize interpassive means to flee into self-forgetfulness. Interpassivity is therefore either an anti-ideological behaviour, or it is a second, and entirely different, type of ideology that does not rest on becoming a subject. Not only Althusser's Marxist theory but also Judith Butler's gender theory were preoccupied with the search for such an alternative (see Butler 1995); it was the fundamental question of every theory that sought an escape from ruling ideologies, dominating models, hegemonic identities and so on. Interpassive behaviour seemed to present an unexpected answer. At this point, it seemed obvious to take sides, not only with interpassivity's theory, but also its practices.

<div align="center">8</div>

The rituals of interpassivity, its 'little gestures of disappearance', resemble acts of magic. Just as Haitians liked to spare themselves the need to kill their enemies by carefully piercing a doll, hordes of interpassivists spare themselves entire evenings in front of the television by carefully programming their recording devices. As in ritual theory, even here we can productively turn the explanatory relations around in the other direction: not only must interpassive behaviour be understood as an unperceived 'magic of civilised people'; it is also necessary to recognise the interpassive

dimension of all magic. *Magic relies, in principle, on not believing*; Ludwig Wittgenstein in his notes on Frazer and Sigmund Freud in his essay about fetishism had already noticed this in an unspectacular way (see Wittgenstein 1993a; Freud [1927a]).

However, if magic rests on not believing, what are we to think of the 'disenchantment of the world' that we are observing at present? In other words, what are we to make of the increasing hostility towards all elegant and glamorous pleasures, for example, tobacco culture, the use of alcohol, the appearance of sexual stimulants and 'adult language', or make-up and dressing up, and all other appearances that differ from private or mundane behaviour because of their heightened ceremoniousness? Are not the arguments of self-ordained health guardians always based on the assumption that 'well, earlier, it was believed that . . .' (e.g., that smoking was not dangerous), which the imperialist colonisers had already erroneously applied when observing tribal cultures? Are we not dealing here with something that is always wrongly considered a step towards enlightenment, an emancipatory progress in knowledge? But if it is not, then what is it? Only now does the full momentousness of Max Weber's answer become understandable: neither science nor philosophy cause the 'disenchantment of the world'. Instead, it is religion: the internalisation-oriented religion of Protestantism is supremely hostile to the external practices proper to magic. And this Protestantism can be so radically internalised that it does not even have to be aware of its own religious nature (Weber 2002). Only the *fanaticism* pertaining to 'health religious' movements allows us to discern this religious nature. The hostility against those magic practices that make our lives colourful and loveable stems from religion, and not from any progress in knowledge. Magic never had believers; it always happened against better knowledge

(Mannoni 2003). Therefore it cannot be better knowledge that suspends the magic spell.

The disenchantment of the world seems to be taking place even within the sphere of art. We can observe this, for instance, when in the name of the politicisation of art its contents are forced and its forms ignored. From the perspective of inter-passivity, a question arises, namely, does this translate into a gain in knowledge or is this merely a sacrifice of pleasure and of every possibility for art to process affects? By banishing the magic of art, one potentially does away with its crucial efficiency apropos the social unconscious – and with that, its most important political power.

9

At present, there is a great deal of contemplation in various social contexts of the relationship that emerges between certain activities and the people who observe or engage in these activi-ties. This relationship is usually imagined to be one of increasing identification. It is widely believed that those who watch do so in order gradually to become more like the actors, and ul-timately also to become active themselves – or at least, to be capable of becoming so. Thus, the pleasure experienced by people who remain immobile while watching sport on tele-vision is nowadays usually explained by the theory of 'mirror neurons'. These realisations, however, pose more questions than they answer: for example, the appropriate research would have to examine whether the fact that many people currently do not cook, but instead buy ever more beautiful cookbooks, can really be explained through a hypothesis of 'non-mirroring neurons'.

The idea of refraining from great deeds through miniature play is, in any case, of key importance for all questions concerning, for example, the relation between violent computer games and violent acts by youths, or the relation between pornography consumption and sexual violence by adults (or, for example, between S/M games in Nazi costumes and real fascist activities). Might it not rather be the case that such games, like magic acts, function as a defence reaction and actually spare the actors from committing real acts of violence? Is it not conceivable that games might have a 'cathartic' function in the Aristotelian sense? Is it not the case that young people who build up a lot of aggression during a school day might have to shoot things on a computer for a while so that they can go to school the next day more or less relaxed?[8]

From the point of view of the theory of interpassivity, the fact that the games in question have in recent years come under increasing suspicion of abetting real acts of violence points towards an emerging theoretical weakness in *common sense* understanding. This weakness lies in the increasing inability of contemporary culture to imagine that playing games could have a potentially defensive function. The whole idea, brilliantly presented by Jacob Bernays, that the 'cathartic' function of theatre in Aristotle's theory has to be understood precisely in this way has become unthinkable when it comes to video games (Bernays 1979). This diminishing awareness can be understood as an effect of the 'disenchantment of the world'. A type of 'iconographic naivety' permits common sense always only to compare the content of a game with the content of a violent deed, and then to infer unambiguous, grievous conclusions about the game itself (without, however, typically extending these to other games, such as, for example, chess or bowling,

which would be the logical thing to do). Equally, the idea that a *complementary* relationship between the game and the deed can actually emerge, precisely due to the identity of the content and the concurrent difference of functions, becomes hard to comprehend and imagine. Moreover, there is not even a trace of an idea of posing the question of the relationship – the 'articulation' – of these two practices (for this notion, see Althusser 1993: 149). Yet it is the job of cultural theory to observe and analyse such historically evolving or currently proliferating epistemological inhibitions and difficulties in thinking.

10

Since many practices of contemporary culture do, indeed, develop in the direction of increased 'avoiding through playing', common sense's difficulties in thinking are all the more conspicuous. What remains unnoticed in theory enjoys increasing popularity in practice. Once again, the blindness of awareness seems to provide favourable conditions for the prosperity of its object. 'Cultural capitalism' or the share of 'immaterial labour' in contemporary consumer goods precisely consists in the product's function of avoidance. As Slavoj Žižek remarks, today's material objects increasingly serve as props for an experience, for participation in a particular lifestyle or conviction (Žižek 2002a: 118). Certain apples are not just fruit, but a promise of a health-conscious life or even an expression of ecological protest. Special training shoes serve not only as sports equipment, but also as fashionable props and a sign of an informed protest against child labour in China or even, precisely thanks to their specific logo, as a definitive overcoming of that very logo craze (on this, see Ullrich 2003: 128).

12

Yet it would be almost impossible, at least in the history of capitalist production methods, to find products that had not already been charged with such meanings. Roland Barthes analysed this clearly in *Mythologies* (Barthes 2013): for instance, a car such as the famous 'DS' introduced in 1955 by Citroën was not simply a means of locomotion, but was simultaneously a 'myth' that translated in this case into a promise of modernity and utopian elegance. If we want to conceptually distinguish 'cultural capitalism' from capital's traditional exploitation of labour, it is the changed quantitative relationship of the two that offers itself as relevant criterion (for example, advertising, myth creation, branding, etc., would in previous periods have amounted to less than 50 per cent of the value of a product; today, on the contrary, these aspects account for much more than this).

If there is a precise dividing line here, then it does not run between the presence of a myth and its absence. Instead, the decisive question is the following: is the myth one of participation or does it already have the interpassive dimension of avoidance typical of our era? Customers who purchased a Citroën DS probably wanted visibly to belong to a new era. Today, on the contrary, the majority of customers who buy four-wheel-drive off-road vehicles or so-called SUVs live in the city. They most likely know only from hearsay of rural life and of terrains that are difficult to drive on. The rough-and-ready car provides them a sense of 'off-road' without ever having to go there. While the philosopher Alain wrote pointedly at the beginning of the twentieth century that 'what the city dweller especially likes about the country is the going there; action carries within it the object desired',[9] today, when it comes to cultural capitalism, this wording must be turned on its head: what the SUV owner likes about the countryside is precisely the fact that he does not

go there. The 'not doing' provides the basis for the fulfilment of his desire. Possession of an off-road vehicle, even if it only looks like one, such as an SUV without four-wheel drive, saves him from ever having to make an off-road trip. The characteristic of cultural capitalism is, as Mark Slouka clear-sightedly remarked, precisely that a bit of life is purchased along with the product (Slouka 1995: 75; see Rifkin 2001: 171) – and, furthermore, with the goal of not having to live it. The SUV takes care of it for us – it is rural leisure, in a similar fashion to an apple that is healthy in our place, or to trainers that are athletic on our behalf (after all, trainers are increasingly being worn by people who do ever less sport). In other words, cultural capitalist goods are dispatchers of vicarious life; they are interpassive media.

11

A pressing question arises, namely, why do people not want to have their lives and their pleasures? Why do they aspire to be substituted by other agents in precisely these areas? As we had to recognise in the examination of rituals,[10] interpassivity has to do with the sacred, indeed, the cultural 'sacred in everyday life' (according to the concept of Michel Leiris [2016]). Since inter-passive behaviour always aims at avoidance, we must understand it as a behaviour that fends off this sacredness. People therefore always engage in interpassive behaviour when they fear that they would otherwise experience too close an encounter with something sacred. This applies also to the use of cultural capital-ist leisure products that serve for the avoidance of life and leisure itself; since as Paul Lafargue (1883) knew quite well, like life, idleness, too, is sacred among heathens.

This defensive, 'apotropaic' movement displays traces of the oldest, most infallible way of behaving towards the hallowed in culture: dread. That which is sacred is anything but agreeable or easily compatible. Instead, it is ambivalent and for that reason is described with words that mean both 'sublime' and 'dirty' (see Freud [1912–13]: 311). Against this backdrop, it becomes clear how amiss current practices are that steadfastly attempt to have people encounter particular things 'participatively', or that measure the usefulness of museums, now typically privatised and legally independent, by the number of visitors. After all, sites such as museums do not fulfil their main function by being visited! Instead, their greater usefulness consists in knowing that the art in them is in good hands and that one does not need to constantly visit them in order to see it.[11] The notion that such sites would be useless if human faces did not parade one after another in front of the artifacts is not only strange, but it has also forgotten culture. It originates in a quasi-childish trust in the boundless digestibility of cultural objects – a blind trust that owes to the blindness with which we use things in everyday life, such as the off-road vehicle.

12

Most of the essays in this volume have been published in other languages, the only changes being to the bibliographical references, which have been standardised. The idea of the volume is to make it possible to follow the development of my reflections on interpassivity. Unavoidably, this leads to certain repetitions. I must therefore appeal to your patience, though this is not simply a problem of the narrative rendering. We must remember that

thoughts on interpassivity are intended to reduce paradoxes, to overcome difficulties in thinking and to break barriers to knowledge. When your car is stuck in the snow in a parking space in winter and you want to push it free, this doesn't usually happen with the first push. You have to use a 'rocking' technique, pushing it forward, then letting it roll back again, then pushing it forward again, and so on. And one must proceed in precisely this way when thinking about interpassivity and related issues. The recurrence of particular considerations and examples should not be seen as mantras (albeit, mantras do seem also to possess a fine, interpassive dimension), but instead, as in the case with the stuck car, as a way of gaining momentum.

Notes

1 At the conference 'Die Dinge lachen an unserer Stelle. Interpassive Medien: die Schattenseite der Interaktivität', University of Art and Industrial Design, Linz, Austria, October 1996; see Pfaller 1996 and 1998 (cf. Chapter 1).

2 For example, Umberto Eco's ambiguous utopia of the 'Open Work' (Eco 1989). For a criticism of its philosophical premises, see Chapter 5 in this volume.

3 See Žižek 1998; Dolar 2001; Krips 1999. For Žižek's theoretical method, see Chapter 4 in this volume. Since the theory of interpassivity has proven to particularly require an art of thinking in examples, as is beautifully demonstrated by Žižek, I have added this 'method' chapter to this book.

4 For these developments, see, for example, van Oenen 2006 and 2010; Yoshida 2008; Hiebaum 2008; Johnsen et al. 2009; Kuldova 2016; and the various contributions in Pfaller (ed.) 2000; Feustel et al. (eds) 2011; and Wagner (ed.) 2015.

5 Taking one example as representative of many, I want here to mention the Austrian artist Martin Kerschbaumsteiner's wonderful video 'Kunstaktion "Arbeit"' (parts one and two), https://www.youtube.com/watch?v=UYABLSEyz5I; https://www.youtube.com/watch?v=qv24iFXD9L4 (last accessed 9 August 2015).

6 René Pollesch has referred to interpassivity theory in his plays *Ich schau dir in die Augen, gesellschaftlicher Verblendungszusammenhang* and *Calvinismus Klein*. For his collaboration in this matter with Christoph Schlingensief's production *Sterben lernen* in Zurich 2009, see http://www.welt.de/kultur/theater/article5448961/Seid-nett-zu-den-Eidgenossen.html and http://www.nzz.ch/gebetsmuehlentheater-1.4121040 (last accessed 9 August 2015). Schlingensief also referred to interpassivity in his blog: https://schlingenblog.wordpress.com/2009/12/page/3/

7 For this, see Chapters 1 and 2 in this volume.

8 I have elaborated on this more extensively in my book *Second Worlds* (Pfaller 2012).

9 Alain 1973: 242. For questions concerning urbanity and interpassivity, see Chapter 7 in this volume.

10 For this, see Chapter 3 in this volume.

11 For this, see Chapter 6 in this volume.

1

The Work of Art that Observes Itself: The Aesthetics of Interpassivity

One would like to say: This is what took place here; laugh, if you can.
Ludwig Wittgenstein (1979: 3)

1

Given the fact that a whole series of phenomena have cropped up in culture and in contemporary art, a new term had to be introduced: the concept of *interpassivity*. To get an idea of this concept, let us imagine the following scenario. A man goes into a bar and orders a beer. Then he pays for the beer and asks someone else to drink it in his place. When the beer has been drunk by the other person, our hero leaves the bar with a certain feeling of satisfaction.

This little story, strange as it may seem, nevertheless reveals the structure of a truth as it is embodied in a number of quite common everyday acts. For example, the way some people use their video recorders: they programme these machines with great care when leaving the house in the evening, in spite of

the fact that interesting movies are being shown on TV. Back home, the video freaks anxiously check to see if the recording has taken place, and then, with a certain relief, they put the tape on a shelf – without ever watching it. But they have already experienced a deep satisfaction the moment the tape with the recorded movie was taken out of the machine: it was as if the video recorder had watched the movie in their place (see Adams 1997: ch. 2).

Delegating some *work* to others is a common rule in the use of machines as well as in the social division of labour and of classes. This principle also underlies interactive installations in the arts where an artist tries to delegate some artistic work to the observers. But this new phenomenon seems quite paradoxical and difficult to grasp theoretically: what is taking place in the cases of the beer drinker and the video recorder is a delegation of *consumption*. It is not difficult, productive activity that is being fulfilled by someone else or by a machine, but, conversely, a pleasant consuming attitude (a 'passivity', as the proponents of interactivity would say). The *enjoyment* of something is – partly or even totally – delegated to other people or to a technical device.

Entirely in keeping with the notion of 'interactivity', we would like to introduce the term 'interpassivity' for this strange practice. A certain transfer takes place in both of them: in the case of interactivity, some activity is transferred from the producer or from the product to the consumer (in the case of interactive art, from the artist or from the work of art to the observer); in the case of interpassivity, some passivity is being transferred from the consumer to the product. In the case of interpassive art, a masterpiece would observe itself, relieving the observers of this task (or pleasure).

2

The capacity of artworks to observe themselves has found large resonance within contemporary art. Several current and post-modern art trends can be understood as a direct reaction to this: in particular the recent 'non object-centred' arts (such as contextualism, institutional critique, postcolonial critique, neo-situationism, social interventionism, service art, etc.), aspects of which were so predominant, for example, at documenta X (June–September 1997) and documenta XI (June–September 2002) in Kassel.

These new 'non object-centred' tendencies refer to the artwork's capacity for self-observation as something to be resolved. According to them, traditional ('object-centred') arts already contain something that should not be included in the work, but should be left to the observer. Finding the artwork, discerning it among ordinary objects outside a typical art context, honouring the absence of traditional forms of presentation as a 'contemporary form of non-spectacular dramatization',[1] and so on – all these tasks should now be left to new, skilful observers (who are for the most part art producers themselves). This implies that, in 'object-centred' arts, the artwork itself (and its traditional context) had fulfilled these tasks. Traditional observers had delegated them to the masterpieces. The masterpieces had interpassively performed these parts of the observation themselves, in advance of any possible observer. The new tendencies aim at reappropriating this pleasure of reception and giving it back to contemporary observers. The artworks have to be deprived of this pleasure that they previously had stolen – therefore artistic products constantly appear, in current postmodernism,

as extremely modest, poor and ascetic; they seem to merit the description of 'weak art' (*arte debole*).

Precisely this idea of self-observation by the artwork is seen under the opposed perspective in modernism and the classical avant-garde. It can still be found in works of contemporary art which are based in these traditions. The presence of writing within visual arts, for example (in artists such as Jenny Holzer, Joseph Kosuth, Roni Horn), is to be seen as reflecting a desire for a kind of writing that reads itself. In its material, spatial presence, and especially in light installations that present a text, writing appears different from its 'absent' existence in books. It is staged in a way that in itself strongly resembles reading. Therefore this writing always sends out the underlying message 'You need not read this.' Some texts of classical avant-garde literature, for example poems by Gertrude Stein, with an abstraction that results from their continuous repetition, appear as if they had been written not for books but for such a presentation. Tibetan prayer wheels testify to the same principle on the level of traditional culture (cf. Žižek 1997: 34). Just as these religious devices may have marked a moment in a culture's emerging alphabetisation, so the current 'literacy' within visual arts appears typical of an epoch of increasing an-alphabetisation, a period after the 'end of the Gutenberg galaxy'.

The problematic of self-observation has been at work in its most serious and tragic dimension in the discussions about the Holocaust memorials in Berlin and Vienna. In this context, the question incessantly appears: should we construct a big, visible sign expressing our readiness to come to terms with history, or is there, on the contrary, the danger that precisely such a monument could relieve everybody of the need to remember

the Nazi crimes by presenting the work of memory as something already done? Especially in this field artists like Jochen Gerz are looking for solutions that function according to a principle of absence, not presence (see Lehmann and Weibel [eds] 1994). Here, in particular, presence appears susceptible to the suspicion of self-observation and the dismissal of the real observers.

Another phenomenon within contemporary art also seems to reflect the urgency of the question of interpassivity: the 'proliferation of curators'. Hardly any art manifestation seems possible nowadays without a curator (sometimes even several layers of them) on the job. It appears very likely that these people are an interpassive element: a stand-in for the observer, an instance of observation already included in the artistic manifestation. But what could have made such an instance necessary? This seems to result from the problem of an 'economy of attention' (Franck 1998), an economy of art observation. It is conceivable that, among other factors, interactive art – which tends to transform observers into artists – has contributed to a shortage of observers. As a consequence, almost no one wants to see anything other than the results of his or her intervention in the interactive installation – a purely narcissistic desire. The more interactivity we have, the fewer real observers, interested in something apart from themselves, can be found.

Therefore the invention of interactive installations seems to require, as its counterpart, the installation of interpassive media, such as curators. This can also be seen on the level of everyday life with the Japanese 'tamagotchi'. This interactive virtual animal has made necessary an even stranger interpassive invention: a special video for the entertainment of cats and dogs – a virtual instance which can take care of real pets when their real owners are busy with a virtual beast.

3

But interpassivity is not only manifest as a problem *structuring* contemporary art (and everyday life). In several cases it has also been made the *subject* of a work of art. In so-called contemporary 'service-art' for example, which constructs social situations by offering services to the observers, some artists also deal with the problem of delegated consumption. On closer scrutiny, some of the public 'services' they offer are rather strange. Their structure is sometimes like this: 'You have a sandwich in your pocket? – The artist will eat it in your place.'

To illustrate this with some concrete examples: in Berlin in spring 1998 the artist Ronald Eckelt made a special offer to car owners. They could give their car to him, and he would make it ready for the scrap heap, driving it to destruction in their place (cf. Stepken 1998: 54). For the exhibition series 'Willkommen, Bienvenue, Welcome' in Vienna in 1996, the artist Ruth Kaaserer set up an 'order service' which consisted of attending the appointments and rendezvous of visitors in their place. The consumption of one's personal friendships was also to be delegated in another project: Astrid Benzer offered a service which consisted of writing and designing private invitation cards telling the friends and relatives of the exhibition visitors to 'come by some time'. An interesting point about this project for our theory was that in order to avoid even the modicum of effort that goes into writing a small postcard, the visitor had to fill out comprehensive questionnaires detailing the type of relationship that existed between themselves and the addressee, the desired tone of the message and so on. This proves, first, that in this case there was not a delegation of work, but of consumption (since it made even more work necessary) and, secondly,

that interpassive people who are lazy about writing are willing to do absolutely anything to avoid writing – including writing! (A structure typical of obsessional neurosis.)

But service-artists have even more interpassive possibilities: if they do not offer themselves as substitutes to consume the spectator's enjoyment, they can also delegate their own enjoyment. In Linz in 1998 the artist Martin Kerschbaumsteiner advertised for a 'workman for some easy garden work'. But having found the workforce (the Marxian *Arbeitskraft*) that he was looking for, he did not consume it by letting it work. Instead, he used it to let his own effort be consumed. The artist dug the hole in the garden himself and filled it again himself, while the workman had to sit on a chair and earned his money by watching the whole action.[2] An example of artistic dealing with interpassivity within a more object-centred art would be the 'energy annihilation machine' (*Energievernichtungsmaschine*) designed by the German painter Jiri Georg Dokoupil: a big black cube which simply consumes electrical energy without transforming it into any useful or at least perceptible effect.

A famous presentation of interpassivity in literature is to be found in the trilogy *Les Lois de l'hospitalité* (The Laws of Hospitality) by Pierre Klossowski. Here we have a hero who is convinced that he owns his beloved wife even more when he gives her away to others. The narrator notes: 'My Uncle Octave [. . .] suffered from his matrimonial happiness as from an illness of which he believed the only cure to be to pass it on to others.'[3]

All these examples of artistic ways of dealing with interpassivity seem to show that not only self-observation, but also a certain theoretical self-reflection, can be discerned within art. And this philosophy 'in a practical state' (see Althusser 2006: 32), which occurs implicitly within some works of art, seems

capable of contradicting the loud, explicit philosophies that are 'spontaneously' and hastily proclaimed by some artists (and by their media theory authorities). The discovery of interpassivity ('practically' included in some works of art), for example, reveals the fact that the 'theories' of interactivity that have been so predominant in recent years have actually blocked theoretical reflection – they function as a real 'epistemological obstacle'. For the opposition of 'activity' and 'passivity' that these philosophies of interactivity suggest is incomplete. There is a third possibility: observers who are neither active nor passive. Sometimes the observer not only fails to assume 'activity'; it can also be that 'passivity', observation, does not take place on his part, since this is assumed by the work observed.

By introducing the term 'interpassivity' we would like to give a theoretical formulation to the implicit philosophies at work in contemporary art, and to help overcome the theoretical obstacles constructed by some spontaneous philosophies[4] – obstacles in theory which, conversely, had their negative effects on practical artistic production. The large number of boring interactive works that followed the first, 'heroic' efforts are evidence of this statement.

4

In the arts, interpassive structures seem to have been around for a long time. They have even been the subject of some artworks. Theory, by contrast, has discovered them only quite recently, and – up until now – only partially. Even the theories of an 'aesthetics of reception' which coined famous formulas such as 'the implicit reader', 'lector in fabula' or 'the observer within

the image' have missed this point in a symptomatic way: these theories only referred to the idea that every artwork is 'open' in its signification and requires interpretation by readers. 'That the recipient is included in the work' means here precisely that he or she is not included in it in the sense of interpassivity: the 'open' works that require contextualisation and interpretation do not comprise an interpassive agency which fulfils such tasks in advance of any possible recipient – and in his or her place.[5]

Jacques Lacan, on the contrary, has really discovered such an interpassive structure. As Lacan pointed out, the Chorus may have had the function of a spectator present on stage in Greek tragedy. The Chorus experienced compassion and fear (*eleos* and *phobos*, in Aristotle's terms) in place of the real spectators, who were glad to be relieved of this task (Lacan 1986: 295). Slavoj Žižek has commented brilliantly on this passage by comparing the mechanism of Greek tragedy to that of contemporary TV comedies ('sitcoms'), such as *Golden Girls*, *The Munsters* or *Married . . . with Children*, with their so-called 'canned laughter' (Žižek 1997: 33–5). Here a certain mechanical laughter is always already built-in, erupting after every joke and before any possible laughter on the part of the spectator. Therefore these works of popular culture are not only that which is amusing but also that which is amused. The programme laughs about itself.

But what is the function of this self-amusement in a popular cultural product? With the example of canned laughter, a certain 'overdetermination' can be rendered visible, a mulitiplicity of possible explanations which may have obscured the phenomenon of interpassivity for a long time.

5

As a first step, it appears simple enough to explain the use of canned laughter as an attempt to 'infect' the real TV viewers. Canned laughter would, according to this explanation, be a 'starter', creating a certain mood which makes it easier for a given joke to be effective, that is, to make the viewers laugh (see Freud [1905a]: 126; Freud [1921]: 107). By sharing this mood, the viewers would identify with the laughing agents contained within the programme. They would laugh *with* the canned laughter.

But a similar phenomenon might also suggest an opposite explanation. The principle of a laughing reaction already built in appears to be standard in an ever more rampant phenomenon: the culture of the bad joke. Certain contemporary TV and radio entertainers have cultivated this habit: they tell extremely tasteless and for the most part pointless jokes followed by a loud cackle of laughter. Here, the anticipation of laughter on the part of the entertainer appears to make possible another, secondary laughter on the part of the listener: laughter about the fact that there is apparently someone who finds the joke funny, but also pleasure over the fact that one is not laughing at the tasteless joke itself, but at something else. What is funny here is precisely that there is nothing funny about it (but that there is still an idiot who laughs). We could call this dialectic approach 'working with a presupposed idiot'. The listener's reaction in this case is not to laugh *with* the canned laughter, but to laugh *against* it – to laugh about the presupposed idiot. In Freud's terminology, this means that it is an amusement related not to the *joke* but to the *comicality* of the laughing idiot's behaviour (cf. Freud [1905a]: 180–99).

The idiot, of course, renders possible the same idiotic behaviour on the part of his listeners, but accompanied by a different consciousness. They laugh, too, but not for the same reason (or so they think). Precisely what makes them identical with the idiot (their shared laughter) is regarded as the mark of difference that distinguishes them from him. The *projective* attribution of amusement to the other is a condition for the listeners' own amusement. The false consciousness is necessary for the existence of the phenomenon at hand: without this minimal misrecognition about its own conditions, their laughter could not take place.

This culture of the bad joke not only recapitulates on a mass-culture level the key features of the intellectual culture of 'camp', as described by Susan Sontag (Sontag 2001b) (a culture which can be characterised as follows: 'What is so tasteful is precisely the fact that there is nothing tasteful'). It also reminds us of the aesthetics of the sublime, as described by the antique author (Pseudo-)Longinus as well as by a number of philosophers up to Immanuel Kant and J.-F. Lyotard (see Kant 2008; Lyotard 1989). The logic of the sublime can be expressed as follows: 'This is so beautiful because there is nothing beautiful in it.' The total absence of beauty itself is regarded here (by 'subreption', as Kant notes,[6] a term analogous to the Freudian 'projection') as a feature of beauty.

This dialectic structure also involves, for Kant, the presupposition of an idiot: Kant has to imagine that he himself could fall from the top of the mountains (which Kant perceives as horrible products of nature without any discernible regularity or beauty). But the fact that he is in reality safe reverses the character of the whole experience for Kant and renders it in a sublime way pleasant. The principle 'it is so pleasant since there is nothing

pleasant about it' can be reformulated as 'it is so pleasant since it is not me (who finds it pleasant or who is the victim)'.

The culture of the bad joke, 'camp' and Kant organise their aesthetic pleasure by sending away an imaginary predecessor whom they allow to fall into the abysses of bad taste or nature. Thus they can enjoy their distance from that presupposed character. All three of them are aesthetics of a projective going at a distance.[7] They always need a first (at least imagined) spectator in order for enjoyment against him and his experience.

<div align="center">6</div>

But identification and projection are not the only mechanisms of an aesthetic pleasure based on another agent. To laugh *with* or to laugh *against* the canned laughter are not the only options. As Slavoj Žižek has pointed out, it is also possible for a viewer of a programme with canned laughter not to laugh at all. We can feel the emotions required through the medium of the other: 'even if, tired from a hard day's stupid work, all evening we did nothing but gaze drowsily into the television screen, we can say afterwards that objectively, through the medium of the other, we had a really good time' (Žižek 1997: 35). This is the third possibility for explaining canned laughter: remaining quiet, without any expression of amusement, we can yet laugh – we laugh *through* the other.

On the level of traditional popular culture, as Žižek has remarked (1997: 35), the phenomenon of 'weepers', still well known in some Mediterranean cultures, could be explained in this sense. These women cry instead of us. We, calm ourselves, cry through them. Such delegations can take place consciously,

or without us noticing them at all. We might think that we, ourselves, did not share the feelings that are being felt in our presence, since in our psychological interiority we cannot find them. But what counts is the fact that these feelings are being expressed before us, in our presence. This is why they are ours.

Žižek has illustrated this with respect to the above-mentioned Tibetan prayer wheels:

> [I] write a prayer on a paper, put the rolled paper into a wheel, and turn it automatically, without thinking [. . .] The beauty of it all is that in my psychological interiority I can think about whatever I want, I can yield to the most dirty and obscene fantasies, and it does not matter because – to use a good old Stalinist expression – whatever I am thinking, *objectively* I am praying. (Žižek 1997: 34)

I might think that I was just succumbing to my dirty fantasies – but no, the presence of the spinning wheels or of some hired praying people would objectively change the matter: what counts is the ritual that I am taking part in, not my personal consciousness which might conceal my immersion in the ideology whose rituals I follow. My dirty fantasies are therefore more of an illusion by means of which I misperceive the simple truth of my religious belief. Or they might even be its required supplement, necessary to sustain my conviction that the stupid rituals were not what counts. The fantasies (like a deep 'inner' belief) would thus prevent me from ever being able to say, 'These are the religious rituals I follow. This is what counts, this is my belief.' A true believer, according to Blaise Pascal, must never be able to say 'this is it' – otherwise he or she falls prey to superstition (Pascal 1965: 233–4, §469).

This explains the paradox of how I am connected with these outer agents: it explains the fact that delegation is *working at all*

and that it is *working for me* – and not, say, for somebody else (for example, the owner of my borrowed prayer wheel). The connection is not just a product of my own imagination. On the contrary, my imagination is that I am not praying through the device. But I am performing the ritual, it is taking place in my presence, so I can be 'objectively' identified as a believer – and this identification by others necessarily entails my own identification (which is concealed by the products of my imaginary).

From these phenomena Žižek has drawn the conclusion that our innermost psychic contents have nothing 'psychological' about them. It is possible to feel them objectively, through outer agents: 'This is how we should grasp the fundamental Lacanian proposition that psychoanalysis is not a psychology: the most intimate beliefs, even the most intimate emotions such as compassion, crying, sorrow, laughter, can be transferred, delegated to others without losing their sincerity' (Žižek 1997: 34).

This paradoxical possibility of delegating one's feelings and feeling them through others seems to remind us of Ludwig Wittgenstein's reflections about feeling pain in someone else's hand. Wittgenstein even thought of a total delegation where one, in entire personal anaesthesia, would only feel through outer agents (cf. Wittgenstein 1981: 90). A similar idea is encapsulated by Deleuze and Guattari who conceived the famous 'body without organs' and described a rejection of all 'desiring machines' by this body (Deleuze and Guattari 2000: ch. 1, pt 2).

But what has been described by Žižek is not only the possibility that what I regard as my pain is located in somebody else's hand. It contains an even stronger 'alienation', for not only can I feel my amusement, grief or religious belief without being aware that they are located in an outer agent; I can even be unaware of the fact that I have these feelings at all. It is

therefore possible to experience amusement, grief or religious belief *without even noticing it.*

7

Yet beyond this last and most sophisticated way of using canned laughter, there is still another type of delegation which seems to require a bit more explanation. Not only can I watch a TV comedy and let it laugh in my place, I can even record it on a videotape and never watch it. Not only can I 'objectively' amuse myself while I am apathetically present but I can even watch TV *in effigie*, having made sure that another agent does it in my place (while I am – in engaged participation or in apathy – present somewhere else). Not only the amusement during the reception of the comedy, but also the reception as such can be delegated.

It is not only possible to attend a certain event and let the required feelings be staged by others. It is also possible to enjoy a pleasant event *in absentia* by sending representatives. With this new idea questions arise in two directions. On the one hand, concerning the nature of pleasure and enjoyment: why is it pleasant acts in particular that are being delegated? Whereas the advantages of delegating unpleasant or ambivalent moods or convictions (such as grief, fear, misery or religious belief – and also laughter if it is a matter of politeness) appear evident, the delegation of pleasant feelings and acts seems to require a high degree of explanation. Why do interpassive people always construct these twofold 'concatenations' (*agencements* [Deleuze and Parnet 1996: 65]) which connect an object conceived for enjoyment with a medium of its consumption? First one has a nice pet, and then a video for it; first a TV set, and then a video

recorder; first a telephone, and then an answering machine; first an art collection, and then a public institution that possesses it in one's place; first a beloved person, and then a lover for him or her; first one wants a joke to be made, and then one is glad if somebody else laughs at it. What is the benefit that inter-passive people derive from letting the means of their pleasure be consumed by others? What is the gain, the specific satisfaction in delegating one's pleasure? How is it possible to enjoy through the other? And even if this strange mediation is possible – why do interpassive people put something between themselves and their enjoyment to begin with, just as Hegel's master puts the slave between himself and work? Why don't they want to ex-perience all their pleasures themselves, and directly?

On the other hand, questions arise concerning the type of connection that exists between the absent person who enjoys *in effigie* and his or her outer agent. Can the experience of pleasure be delegated in the same way as some other feelings or convic-tions? Is it possible to claim that I was enjoying objectively, just as one can say that objectively I am mourning or that objectively I am a religious, reactionary, progressive or traitorous subject, without knowing it? And if so, what is the connection between the present agent and the absent person? In other words: *who* is being represented in an enjoyment *in effigie*? If weepers weep for all the people *present* at a funeral, do video recorders then watch TV for all the *absent* people? Can my representing agent also let him or herself be represented by someone (or something) else? And for whom does that new agent then experience the pleasure – for the other agent or for me?

Finally, there is the question of the relationship between pleasure and absence in these acts. Is it conceivable that this relationship is in some cases not only contingent, but necessary?

Is there behind the regret (expressed by sending representatives) of not being able to attend the pleasant event also a certain secret enjoyment of this fact? Might delegation not only be able to transmit a remote pleasure, but even to constitute a new one? Can an absence of pleasure sometimes be identical with the pleasure of absence?

8

A first, 'soft' explanation of interpassive phenomena would say that we delegate our pleasures and pleasant feelings to others in the case where, for some reason, we cannot have them ourselves. Another agent serves as a 'prosthesis' through which we can experience at least a portion of the pleasure, if our bodily limitations do not permit direct experience. A pleasure would therefore be delegated in order not to lose it altogether.

An artistic example of this is a little performance by the writer Salomo Friedlaender who published his works under the pseudonym 'Mynona' (which, too, could be regarded as an interpassive delegation of his identity). Sitting in a coffee-shop in Berlin, at a table with Karl Kraus and Adolf Loos, and suffering from the heat, Friedlaender is said to have pulled out his watch and let it slowly slide into his glass of water, accompanying this act with a relaxed 'Aah'. As an explanation, he remarked, 'This is really refreshing' (see Exner 1997: iv). In a similar way, Franz Kafka also sought refreshment through the other. He was the real hero of our opening story: it is said that in the last months of his life, Kafka, unable to drink cold beer due to his tuberculosis, sometimes went to a restaurant in the village of Kierling and invited somebody to drink a beer in his place.

If, in these cases, delegation of a pleasure is being practised in order to have at least a small part of the pleasure and not to lose it altogether, the additional question arises of how this small advantage is made possible. Does this soft, substitutive pleasure work in the same way as was shown before with respect to grief, compassion, fear, amusement and religious belief? Can pleasures be felt 'objectively' through others in the case where one cannot have them oneself? Is it helpful to be identified by others as the one who enjoys in the case where one cannot identify oneself with this role? Can public opinion convince me that I am having fun?

<div align="center">9</div>

It might be argued (although not easily) that the enjoyment of the pleasures last mentioned was performed in the presence of their authors and that, therefore, Friedlaender and Kafka 'objectively' felt refreshment through the others. But there are other examples that resist this explanation. For instance, there is a man who has a friend in New York. Every time he learns that some other person is going to New York, he tries to make them meet his friend in his place. Another strange character has the habit of organising business meetings that he cannot attend himself and thus sends a representative, instructing him or her 'just to speak to the other person, he or she knows quite well what this is about'. But then the person whom the representative meets turns out to be as uninformed with regard to the matter of their meeting as the representative him or herself. The meeting thus assumes the character of one described by Alphonse Allais: a couple in love attend a masked ball. In a hidden place at the appointed time they

meet and then take off their masks – but both of them turn out to be somebody else (Allais 2007). In the case of the delegated business meeting both people are, of course, pretty much the same – that is, representatives of their delegator who is, in this way, as it were, meeting himself. A more common habit is to give to a person who is going away for a long time a certain, beloved object. The object accompanies the person we miss in our place.

In these cases, again, it is not only a certain feeling that is delegated to others in the presence of the delegator – the pleasure as a whole is delegated to them. And, unlike the cases of Friedlaender and Kafka that we discussed before, this pleasure is experienced while the delegating person is absent. Therefore we can no longer claim, as we did before, that somebody was 'objectively' meeting his friend through others. There are no others available who could function as 'subjects' for this 'objectivity': people who could objectively identify the interpassive person with her enjoying stand-in. There is no public who would see the hero's presence at the event and whose attribution of enjoyment would therefore be stronger than the hero's own imaginary non-involvement. On the contrary, in this case the delegator's connection with the phenomenon seems to be entirely a product of his imagination without anything objective about it – nobody else but him would claim the existence of such a connection. While in the cases of canned laughter, prayer wheels and so on the hero was amused, believing and so on without knowing it (while everybody else knew), he is in these cases almost the only one who knows. Other people would not know and would hardly believe him if he told them.

The acts performed by Friedlaender and Kafka also seem to be of this kind. They appear to have the strange quality that their meaning is – like sexual fetishism – only known to those who

perform them. (To other people these acts must have appeared enigmatic or a joke.)

Looking back, we can now also apply this new explanation to canned laughter: a viewer of totally apathetic appearance could regard canned laughter as his outer agent, just as Friedlaender did with his watch, and thus enjoy his amusement secretly, without letting other people know it. He would, then, enjoy as it were 'objectively', because he enjoys (by whatever method) through the object, but, on the other hand, entirely subjectively, since nobody else would know about it. The awareness of being the only one having access can be effective here as an additional source of pleasure – an effect that, as has been remarked, plays an important role in fetishism (cf. Freud [1927a]: 154; Pontalis 1972: 12).

However, even worse, the authors themselves might also not become aware of their pleasure – as is usually the case with the video freaks who do not realise that their pleasure is taking place during the recording. They might conceal their own pleasure from themselves by using 'screen explanations' such as 'one day I will view this recorded programme'. These poor characters would thus not recognise a fact already discovered by Spinoza: that happiness is not a reward of virtue, but virtue itself (cf. Spinoza 1955: 270 [*Ethica* V, prop. 42]). Video freaks unaware of this would therefore be unable to experience the happiness already implied by the virtue of recording.

10

The pleasant act would thus turn out to be as indiscernible as is, according to Kant, the moral act:[8] others cannot distinguish my

pleasant activity among those that I am merely performing under the pressure of life's necessity (perhaps in order to get future pleasures), nor am I protected from misperceiving its pleasant character. But perhaps, like Kant, we, too, need not desperately insist on the question of how (and by whom) such a pleasant act can be discerned, but can move on to the question of what it is that makes it pleasant. How can somebody experience pleasure from the fact that an outer agent is somewhere consuming a pleasure – even if that agent itself, as could be clearly seen with Friedlaender's watch, does not regard it as a pleasure? What is this paradoxical connection, this secret, pleasant 'sympathy' which is so remote from any altruism or love?

With help from psychoanalytical theory we can give an answer to this question: this connection is established by the interpassive people themselves. They make outer agents such as a watch, a lover or a video recorder work as their prostheses of enjoyment. This is achieved by a substitution: interpassive people substitute one act with another by investing the latter with psychic energy that was previously bound to the first. With the same busy behaviour by which they had before tried to view a certain TV programme, they now programme their video recorders. The 'interpassives' behave thus as if one act were identical with the other. They may not know this, but they do it.

If one act (for example, reading a book) is for some reason not possible, then another one (for example, copying the book) can assume the same function. Photocopying a book provides partial relief from the tension that had originally been connected with the wish to read the book. The connection between the interpassive person and his or her human or objectal substitute is established by a 'substitutive act' (cf. Freud [1909]: 243; [1907]: 124f.). By this, the paradoxical connection with our prostheses

38

for extended, indirect enjoyment is rendered possible: I can secretly experience pleasure through my video recorder since I have secretly (and maybe without knowing it) invested one act with the psychic energy of the other. As it may be a relief to strike a remote enemy by hitting the table, it can also be pleasant to participate *in effigie* in a remote pleasure by means of a substitutive act.[9]

Now the relationship, previously unclear, between the interpassive medium and the absent person enjoying *in effigie* can be explained: the interpassive medium represents the absent person by whom it had been installed in a substitutive act. A video recorder does not view for everyone who is absent, but only for the person who programmed it (or who made sure that it was programmed). By such an act the link is established that privileges some absent people as those secretly enjoying it.

At closer sight, the pleasant character of the substitutive act can be revealed as well. That the psychic energy of another act has been displaced on to this one can be discerned by the special meaning that this small, relatively unimportant act has assumed, and by the special care with which it is being carried out. Symptomatic features are the astonishingly high satisfaction the people acting have when their act has been successful, and the exaggerated anger when it has failed. There is, consequently, a certain discernibility of such a pleasant act — yet its pleasant character is always concealed by the fact that this small act has an explanation of its own and thus resists its understanding as a substitute for a bigger one. In this way spectators as well as the acting persons themselves can be led astray about the true, pleasant nature of these acts.

Yet an important difference between the interpassive substitutions and Freud's concept of the substitutive act must be

noted here. According to Freud, the displacement that results in a substitutive act is the outcome of an intrapsychic conflict in which one and the same act has been striven for and has been repressed (Freud [1909]: 243). Substitutive acts are performed by people who maintain an *ambivalent* relationship with the act they substitute. In the case that a murder, for example, has caused one the wish to commit another murder oneself, some protective measures have to be undertaken that repress that wish – measures that replace a murder, work against murdering and yet bring something of that repressed pleasure back. Intended against murder, they can finally assume the character of murdering (for example, of the previous murderer) (cf. Freud [1907]: 127; [1912–13]: 30).

In most of the cases discussed here (Friedlaender, Kafka, the New York visitors), on the contrary, the way the interpassive people related to their wish was not ambivalent. They were on unproblematic terms with their wishes, and the substitutive act had been rendered necessary only by external limitations. Not an intrapsychic conflict but a conflict between a wish and reality had resulted in substitution – in Kafka's case, for example, the conflict between thirst, the desire for company and the disease that had made drinking beer impossible.

The interpassive people had therefore, in most of the cases mentioned, regarded their representatives as possibilities for extended enjoyment, as prostheses, and had willingly connected themselves with them. Such a connection renders possible an extended narcissism as appears, for example, in the relation-ship with one's children or with gods – instances to which one delegates without envy the pleasures one cannot have (cf. Freud [1914]: 90; [1907]: 127). This extended narcissism is, of course, also one of the main impulses that lead to artistic

production – since the artist tries to give perfection to the work which cannot be assumed by the person. The artworks then enjoy this perfection in place of their creators, who hand it over to them without envy.

Extended narcissism is the secret behind that 'sympathy' without any altruism or love that had appeared so paradoxical before. It is irrelevant whether the representative experiences the act given over to him as a pleasure or not, since delegating pleasures to other people or objects does not have to do with loving these others but with loving oneself; it does not have to do with object-relationship but with identification. By using prostheses of enjoyment, 'extensions of man' in McLuhan's sense, the users appropriate a new, extended image of themselves: they identify, as Freud says, with a 'god of prostheses' (Freud [1930]: 92).

Since in these cases the limitation that a wish collides with is completely external to that wish, the resulting substitutive act is just an imperfect substitute which the gods of prostheses would love to exchange for what it represents. Kafka would have preferred to drink the beer himself or with the other instead of having to enjoy it through him. The indirect pleasure is only being striven for since direct pleasure is inaccessible for reasons that have nothing to do with it. Direct enjoyment would in these cases doubtless be better than its interpassive stand-in, but the latter is still better than nothing at all. The interpassive enjoyment provided by prostheses can only be a part of a lost, bygone enjoyment, but it cannot be a new, original enjoyment.

Here ends the attempt to give a 'soft', reassuring explanation of interpassivity. Without questioning the validity of this explanation in some cases, it has to be asked if it encompasses all interpassive phenomena. Is it not conceivable that the video freak

prefers by far his passion for recording to any TV viewing? And does the use of canned laughter not suggest that there are viewers who are glad that they do not have to laugh themselves? In other words, do the phenomena of interpassivity not indicate a problematic relationship between individuals and their enjoyment? Is there not some evidence that these people are ready to go to some pains in order not to experience their pleasures themselves? But why do they not want them? And if they do not want them, why do they make such an effort that someone or something else should partake of them in their place?

11

That such a problematic relationship between individuals and their enjoyment is sometimes to be acknowledged within the arts as well as within everyday culture has been remarked by Klaus Heinrich:

> Just as the art collector is not interested in his collection and has to transfer it – either, as a Maecenas, to the public, or, subterraneously to the underground safes – just in the same way the buyer of furniture aims at its fastest possible annihilation. The notion of the 'throwaway society' brings to mind the desire structure of the addict, the secret wish for annihilation.[10]

A science of '(libido-)economical aesthetics', as Freud had conceived it (Freud [1920]: 17), would have to theoretically account for such phenomena. It would therefore not only have to explain the strange 'pleasure in pain', as it arises for example while viewing tragedies, but also the reverse phenomenon which occurs here: the paradoxical 'pain in pleasure'.[11] Yet the two-sidedness of interpassive behaviour seems to indicate that

42

the relationship with cultural enjoyment is, here, not only problematic, painful and hostile, but ambivalent. This relationship apparently does not allow simple measures to be taken *against* enjoyment (such as being absent). One has, rather, to undertake *something against and something for it* – in one and the same act (such as being absent, but represented).

This is why the phenomena of interpassivity seem closely related to the models of obsessional neurosis and fetishism as these have been investigated by psychoanalysis. Interpassive acts are, like those of obsessional neurosis, substitutive acts that result from an intrapsychic conflict. They react to a wish that (unlike the cases discussed before) is hindered by reasons inherent to it: it is not only external reasons or limitations in time and space that render its realisation impossible, but a discontent already linked to the wish itself. The substitutive act therefore substitutes something that is already originally lost. Thus the interpassive act is better than anything existing at all: it not only brings back a part of a bygone pleasure, but constitutes a new, original one.

The relationship of the individual to its representatives is thus not organised by an identification. There is no process of perfection taking place by incorporating additional organs: by delegating pleasures the individual does not become a god of prostheses. There is no connecting with prostheses that renders possible the enjoyment of additional pleasures.

What is happening here, on the contrary, is a disconnection. Identity is not being enriched by some additional prostheses, but relieved of some parts that have been omitted. The success of externalisation is not that additional pleasures are added to one's range, but that some pleasures do not have to be experienced any more. The intrapsychic conflict between pro- and anti-cultural tendencies is resolved by delegating the 'wishful

attitude' (*wunschgerechte Einstellung*) – just as in fetishism – to another agent (cf. Freud [1927a]: 156; Mannoni 1985a: 20–3). Instead of a process of ego-perfection by identification, the solving of a conflict by splitting the ego takes place.

Whereas delegation which functions according to the 'connection-type' requires acts that establish the link to the outer agent, the 'disconnection-type' of delegation makes acts necessary that confirm a disconnection. Substitutive acts seem necessary in order to guarantee the splitting off – to make sure that the outer agent remains outer. For the delegated wish only remains pleasant as long as it can be kept at bay. By contrast, the prospect that the wishful attitude could fall back on to the interpassive subject is perceived with fear (cf. Mannoni 1985a: 27–8). Substitutive acts provide pleasure by diminishing and converting this fear.

It seems likely that religious rituals and aesthetic practices are to be understood from this perspective. Every small ceremony, therefore, does not have the function of reassuring the subject about its conviction but of confirming that this conviction is still located at a bearable distance. Rituals thus reassure us about the existence, not of a *God*, but of a *believer different from us* (it may be a real or a mythical person, or even a mechanical device, like a spinning prayer wheel or a burning candle). The formula 'ora pro nobis' – read as 'pray (and believe) in our place' – could be regarded as the basic formula of any religious ritual.

This principle of pleasure from delegating our wishful attitudes also applies to our practices of art and art reception. Octave Mannoni has illustrated this with the example of an actor who, while playing the role of a dead person, suddenly gets a tickle in the nose from the dust of the stage and sneezes. Of course, the spectators burst out in laughter. But, Mannoni asks,

what are they laughing about? Since they themselves knew quite well that the actor was not dead, it seems that they are laughing at the imagined astonishment of somebody who did not know what they knew (cf. Mannoni 1985a: 163).

The basic pleasure of a spectator therefore seems to be an interpassive one: it consists of creating and splitting off another character who serves as a backing for the illusions that one does not share but still finds great. Pleasure in art thus turns out to be a pleasure of continuous 'disidentification' (cf. Mannoni 1985b), of splitting off imaginary spectators. This has, for example, been noted by Jonathan Culler with regard to the pleasure of reading: this pleasure is based on a constant 'splittedness' of the reader who imagines 'what a reader would think'. Reading implies, according to Culler, working 'with the hypothesis of a reader' (1983: 73).

Interpassivity thus appears to be the most general structure of aesthetic pleasure. It is not only at work in special cases like that of canned laughter where the interpassive medium is strikingly manifest. It also underlies the allegedly normal forms of art observation: even in such normal cases, the observation is constantly delegated to 'invisible observers' or 'implicit readers'. This delegation is a necessary precondition for aesthetic pleasure. A theory of interpassivity is therefore the key to a general aesthetic theory.

Yet the consequences of Mannoni's discoveries could cause a major theoretical revolution, not only for aesthetics, but also for mass psychology. For they indicate that social groups can be held together by the pleasures provided by delegation. Interpassivity would thus prove to be a key for the understanding of libidinal mass-bondings. Masses could not only be held together by common identification, as Freud had thought (cf. Freud [1921]: 103ff.), but also by common disidentification, splitting

of the ego and disavowal. Such a transformed concept of mass-bondings would, then, also have important consequences for an understanding of the social function of art. Critical theories of the arts have usually located ideology in the pleasant identifications of the spectators. If, for example, I hope that Romeo can marry Juliet in the end, I not only sympathise with a person, but accept the whole presupposed structures of Renaissance class division, heterosexual monogamy and so on. Critical theories therefore aimed at 'estranging', at destroying the spectators' identifications, or at least at making their mechanisms visible to the spectators (cf. Brecht 1971: 37–40). Some of these theories even claimed that it was necessary to destroy the spectators' pleasure.[12]

The discovery of interpassivity entails at least two implications that contradict this image. On the one hand, it makes clear that ideology – as well as pleasure – in art can be situated beyond the spectators' identification. On the other hand, interpassive people show a lived criticism of those ascetic positions that are unable to see in the pleasure of art anything other than evil. Unlike ascetics, the interpassives are – with all their pain in pleasure – mostly quite aware of the fact that they perform their defensive acts against pleasure only in order to find pleasure. And precisely because they feel such pain in pleasure themselves, they are able to let others experience their pleasure without any envy.

Notes

1 Cf. David 1997: 10. The same stance against the 'spectacular' has been taken by Okwui Enwezor (2002: 86).
2 Performance by Martin Kerschbaumsteiner, Linz, spring 1998, documented on video. The video was awarded a prize at the international contest 'Future Vision Work', August 1998. Cf. *Kunstforum* 143 (January–February 1999): 20.

3 'Mon oncle Octave [. . .] souffrait de son bonheur conjugal comme d'une maladie, certain qu'il était de s'en guérir dès qu'il l'aurait rendue contagieuse' (Klossowski 1989: 107).

4 Of course, the concept of 'passivity' endorsed by spontaneous philosophies of interactivity would also merit closer criticism. Its use in the analogous term 'interpassivity' must thus be regarded as a 'battle on the enemy's ground'. The highly problematic equation of *observation* with *passivity* which is presupposed by the notion of interactivity has been criticised by Harold Bloom (Bloom 2000).

5 For this, see Iser 1972; Derrida 1987; Eco 1987; Kemp 1992. It seems as if the representatives of an 'aesthetics of reception' had, with their theory, given a wrong, 'deferred' explanation, a 'rationalisation' (in Freud's sense) of their formula about 'the reader in the text'. The formula, by itself, apparently anticipates the idea of interpassivity in a brilliant, seductive way. For this mechanism of 'rationalisation of the rational', see Althusser's theory of symptomatic reading (Althusser 2006; cf. Pfaller 1997a).

6 Kant 2008: 180.

7 These aesthetics are reminiscent of Helmut Qualtinger's famous character 'Herr Karl'. When he hears the sound of an ambulance, Herr Karl says, he enjoys the idea of not being the emergency patient (Qualtinger 1995: 186).

8 Cf. Kant 2002: 132: 'In actions actually given in experience, which are events in the world of sense, we could not hope to encounter this connection . . .'

9 Wittgenstein, when considering activities such as burning somebody in effigy or kissing the picture of a loved one, emphasises that these activities are not based on a belief in an effect exerted on the represented object. On the contrary, such an action 'aims at some satisfaction and it achieves it. Or rather, it does not *aim* at anything: we act in this way and then feel satisfied' (Wittgenstein 1979: 4).

10 Heinrich 1997: 55, my translation. For this, see also Anders 1988: II, 19, where he states that in today's society it is not commodities but needs that have become scarce.

11 I have tried to give an explanation of this libido-economical paradox in my book *The Pleasure Principle in Culture. Illusions without Owners* (Pfaller 2014).

12 Cf., for example, Mulvey 1986; Brecht, on the contrary, wrote: 'Unser Theater muß die *Lust* am Erkennen erregen, den *Spaß* an der Veränderung der Wirklichkeit organisieren' (Brecht 1971: 5) ('Our theatre must stimulate a desire for understanding, a delight in changing reality').

2

The Parasites of Parricide. Living through the Other when Killing the Father: Interpassivity in *The Brothers Karamazov*

There is one scene in *The Brothers Karamazov* that particularly attracted the attention of Sigmund Freud. When it is revealed that Dmitri is ready to murder his father Fyodor, the Elder Zossima – totally in contrast to custom as well as to any predictable reaction – sinks on to his knees before him. He bows down at Dmitri's feet until his forehead touches the floor. Freud explains this strange behaviour of Elder Zossima by stating that 'the criminal appears to him as a redeemer'. It is as if Dmitri had taken upon himself a guilt which otherwise other people would have had to bear: 'One does not have to murder, since he has murdered already. But one has to be grateful to him for that; otherwise one would have had to murder by oneself' (Freud [1928]: 190). Regardless of the question of whether this is a correct interpretation of Dostoyevsky's text, the idea that Freud produces here is extremely interesting. The idea says: *You can profit from somebody else's killing of his father. Then you do not have to kill yours.* And this is true even if you do not happen to be brothers.

Freud explains this mechanism of grateful replacement as follows: 'That is not kindly pity alone, it is identification on the basis of similar murderous impulses – in fact, a slightly displaced

narcissism' (Freud [1928]: 190). Yet it remains to ask whether Freud's theoretical concepts of 'identification' and 'displaced narcissism' give a full account of this strange possibility; whether these are adequate concepts for the relationship that Freud has so clearly discovered. It appears, however, that neither of these concepts can cover this phenomenon; and furthermore, they do not work together. These two concepts do not even cover each other.

'Identification', in its basic understanding, would mean that someone is, for example, a great sportsman, and that the other, by identifying with him, would become a great sportsman as well. But this is not the case here. As we have seen, the fact that one has become a murderer does not lead the other to become one as well. On the contrary, the first murderer allows the second person not to become one.

Like 'identification', the notion of 'displaced narcissism' also appears to miss the point. It is true, as Freud has noted, that it is possible to *displace one's narcissism* – which means that one can give one's narcissism to somebody else. One can ascribe all the lovely qualities to the other; those lovely features for which, in narcissism, one loved oneself. Then one can say to the other, for example, 'you are my baby'. Yet in this case one ends up not (as Freud assumes) in identification, but in love. Displacing one's narcissism to the other means making the other an object of love. You love in the other that ideal image of yourself that you, having overcome narcissism, have agreed not to strive for any more. In the case where you love the other, you become able to give him or her your most precious gifts. In love, Freud writes, the ego becomes poor for the sake of the other.

But that is also not the case here. When one leaves the murdering of the father to someone else, it is not because of

love for the other. This is not a gift for someone whom one loves more than oneself. The ego does not become poor for the other. The other is quite indifferent here. It can be anybody, even a stranger. What matters here is just that a certain job gets done, by no matter whom. It should just be somebody other than oneself. The job to be done is yet a specific one: it is not a job of work, but of enjoyment. *You wish the other to do in your place what you yourself want to do.* For example, you want the other to drink your beer in your place. And you even prefer this to drinking the beer yourself. It is better when the other does the job of enjoyment for you than when you have to do it yourself.

This seems to be a strange attitude – a kind of generosity, without any envy. And still this lack of envy is not caused by love. By what other reason does this behaviour become possible? How else can we wish that the other should enjoy in our place? Why do we prefer to live through some irrelevant other instead of enjoying directly, by ourselves?

Luckily, there is a name for this structure: interpassivity.

Interpassivity is the case when somebody prefers to delegate their enjoyment (their passivity) to some other instead of enjoying themselves. So what Freud tries to designate by the term 'displaced narcissism' can be more adequately rendered as delegated enjoyment. To give an example, I once encountered a man who was a big drinker. All of a sudden he changed, and did not drink any more. But he adopted a new passion: he became a perfect host. He would always have a bottle in his hand and take care that the glasses of his guests were refilled, so that he could, as it were, continue to be a drinker through his guests. He had become an interpassive drinker.

The same happens when we use our recording devices in order to watch TV while we are doing something else. We

carefully record the programmes without ever watching the recordings. The recording devices do the job of enjoying TV in our place. People who delegate their enjoyment to some other agent in this way can be called interpassive subjects; their replacements function for them as interpassive media.

Delegation takes place here by *acting as if*. By the help of some other agent we create an appearance: we stage a small representation of our enjoyment, and this allows us to stay away from it. So, in interpassivity, we establish a symbolic representation of our enjoyment instead of really enjoying. *We replace an act by some acting as if*.

This is quite interesting with regard to the question of guilt, as Freud has noted. By creating merely an appearance instead of really doing the job, we shift from an internal master, the superego, to an outside authority, a kind of totally naive observer, who is satisfied by pure appearances and cannot distinguish, let us say, between a photocopier and a reading intellectual.

Superego is a very tyrannical master. It commands us despotically to enjoy. It says: 'Do what you really want'; 'Drink without limits'; 'Watch TV endlessly'; 'Kill your father'; and so on. And superego, as Freud remarks, punishes us for our bad intentions (at least) as much as for our bad actions.

The naive observer, on the other hand, is an authority with much more moderate expectations. He is satisfied with just an appearance *as if*. And he cannot read any intentions. In the order of appearances, for example in politeness – just as in theatre or in dance – the question of guilt does not play any role. What matters is simply how things looked, not how they were meant.

This is the crucial point in Freud's discovery with regard to Dostoyevsky: by acting as if, we can let the act be and still avoid guilt. We can act as if we watched TV, and still let it be. We can

even act as if we had killed the father, and actually avoid it. And we cannot be blamed for NOT doing it.

Acting as if allows us to skip the question of guilt – and, as a consequence, the discontents in culture caused by the superego-imposed feeling of guilt.

.

3

Little Gestures of Disappearance:
Interpassivity and the Theory of Ritual

In this chapter I want to present the concept of interpassivity as a theoretical tool for understanding ritual. This concept, interpassivity, was originally developed for the discourse of contemporary art – where it had a strategic value in criticising the predominant notion of *interactivity* (cf. Pfaller 1997b; [ed.] 2000). For ritual theory, the concept of interpassivity can serve to clarify the idea *that ritual came before myth*; to point out the critical value of this key thesis of the so-called 'ritualists' (Robertson Smith, Wellhausen, Freud, Wittgenstein), without succumbing to the anti-ritualist conclusions that (according to Mario Perniola [1998: 40]) can be drawn from it. With the help of the concept of interpassivity we can show what it means to insist on this thesis, and we can, then, insist on it without ever regarding cultures that have only rituals, but no myths, as primitive.

1 Interpassivity versus Interactivity

Obviously, the concept of interpassivity is opposed to that of interactivity. Interactivity in the arts means that observers must not only indulge in observation ('passivity'),[1] but have to

contribute creative 'activity' for the completion of the artwork. The interactive artwork is a work that is not yet finished, but that 'waits' for some creative work that has to be added to it by the observer.

What could be the opposite of that, the inverse structure? The artwork, then, would already be more than finished. Not only no activity, but also no passivity would have to be added to it. Observers would be relieved of observing as well as of creating. The artwork would be an artwork that observed itself. An example given by Slavoj Žižek seems to perfectly exemplify this construction. Žižek wrote:

> let us remind ourselves of a phenomenon quite usual in popular television shows or serials: 'canned laughter'. After some supposedly funny or witty remark, you can hear the laughter and applause included in the soundtrack of the show itself [. . .] So even if, tired from a hard day's stupid work, all evening we did nothing but gaze drowsily into the television screen, we can say afterwards that objectively, through the medium of the other, we had a really good time. (Žižek 1997: 35)

For psychoanalytical theory, Žižek drew from this example the conclusion that allegedly 'subjective', 'interior' entities such as feelings, emotions, thoughts, convictions and so on can have an 'objective', 'exterior' existence. For us, in the context of art theory, this example was an instance of an artwork that observes itself, an interpassive artwork. The TV comedy laughs at itself – in place of the observers who can delegate their amusement (as their 'passivity') to the artwork. Interpassivity in this case consists in delegated amusement.

2 Delegating One's Pleasure

Starting from this example and its structural idea, we soon discovered that interpassivity is a general, extremely widespread phenomenon in culture. There are a lot of people who not only do not want to laugh but who also do not want to have other pleasures, and strive to delegate them. For example, there are people who use their video recorders in an interpassive way: when they find out that an interesting programme is coming up on TV, they carefully programme their recorders in order to record it. Then they feel relaxed and go out to meet some friends while the programme is shown. Later they come home, they check whether everything has been recorded, and then, with deep satisfaction, they put the tape on a shelf without ever watching it. It is as if the machine had watched the programme instead of the observers, vicariously.

Such phenomena from everyday culture allowed us to develop a general terminology: *interpassivity* is delegated 'passivity' – in the sense of delegated pleasure, or delegated consumption. *Interpassive people* are those who want to delegate their pleasures or their consumptions. And *interpassive media* are all the agents – machines, people, animals, etc. – to whom interpassive people can delegate their pleasures. If, for example, you have a dog that eats your cake in your place, the dog functions as your interpassive medium.

If, for a moment, we leave aside the intriguing question of *why* people wish to delegate their pleasures, we can concentrate upon the question of *how* they do it. This question also, the question of the *method of interpassivity*, turned out to be quite difficult and intriguing. It was here that we discovered the *rituals of interpassivity*.

3 The Rituals of Interpassivity

At first sight, it was very difficult for us to determine how the delegation of pleasure takes place in cases of interpassivity: how can a pleasure be delegated to another person, just as to a machine?[2] What is the link connecting the interpassive person with her interpassive medium? How can we tell, for example, that this video recorder is now watching TV in *my* place – and not, for example, in *yours*?

When someone has an artificial exterior organ, we can see tubes that connect the body with its exterior organ, and, from the tubes, we can easily determine for whom this organ works. But in the case of interpassivity there are no such tubes to connect a video recorder with an absent person, or canned laughter with somebody who does not pay attention. What, then, connects the person with her medium of enjoyment?

To clarify this, another example can be helpful. One may be familiar with the interpassive behaviour of some intellectuals in libraries: these intellectuals find an interesting book, rush to the photocopier, copy some hundred pages, and then give the book back and go home with a deep sense of satisfaction – as if the machine had already read the text in their place. The crucial point in this case of interpassive behaviour is the *figurativeness* of the act: what the intellectuals do (usually without knowing it) is to act as if the photocopier were reading the text. They literally *play reading* by means of the machine: the light of attention, as it were, is shed on every page, one after another, in a linear process; slowly the machine 'looks' at every line and every page.

Figurativeness, and the substitution of a real act (such as reading) by a figurative representation of it (such as photocopying), is characteristic of ritual action. Interpassivity consists in

ritual acts. This ritual character of interpassive practices provides us with an answer concerning the method of interpassivity: the interpassive person and her medium are not connected by tubes, but by a representation. The interpassive person delegates her pleasure to a medium by ritually causing this medium to perform a figurative representation of consumption. The one who ritually causes this act is the one for whom the medium reads, observes, laughs, eats and so on.

4 A Magic of the Civilised

The ritual figurativeness that we have encountered within inter-passivity is especially characteristic of magic action, where, as Sigmund Freud remarked, a symbol assumes the full value of the symbolised (Freud [1919]: 267). For example, in Haitian voodoo, the symbolic killing of a person (through the mutilation of a small sculpture that represents this person) assumes the full value of an actual killing. In the same way the symbolic represen-tation of reading by photocopying assumes for the interpassive intellectual the full value of actual reading, providing him with complete satisfaction. Just as, for the so-called 'savage', an act of voodoo may replace a real act of murder, for the intellectual, an act of interpassivity may replace a real act of intellectual work. Interpassivity can therefore quite aptly be called a magic of the civilised.

The only difference between the 'savage' and our 'civilised' intellectual consists in the fact that only the savage is aware of the fact that he is practising magic. The civilised, on the contrary, is not. What distinguishes the civilised from the savage is not therefore the fact that only the savage is performing magic acts,

but – since both are performing them – the fact that only the savage is aware of it. Being civilised therefore seems to imply a lack of awareness of what one is really doing.

5 Devoid of Any Idea but Still Caught Up in Illusion

This civilised lack of awareness creates a strange position for the interpassive person vis-à-vis the illusion at work in interpassivity. For it is obvious that the act of photocopying in all its astonishing figurativeness stages an illusion – the illusion of reading. And of course, the photocopying intellectuals do not succumb to this illusion. Not for one moment do they believe that the machine could read in their place. They usually *do not even think* of this illusion. They just perform it: they *act as if* the machine could read for them.

This bears out the fact that, devoid of any idea, one can still be caught up within an illusion. The kind of illusion we are facing here is therefore completely different from the structure of illusions as analysed by philosophical tradition – where you have, for example, the image of a hand before your eyes, but you do not know if there really is a hand. In this Cartesian type of illusion you are aware of the image but uncertain about its truth-value. Yet in the illusion we are dealing with here, exactly the opposite is the case: you are completely certain about the image's truth-value (the machine cannot read for you), but unaware of the image (which structures the situation you are in). 'For they *know not what they believe*' – this would be, in biblical terms, the formula for the civilised's position towards the illusion at work in interpassivity.

6 Illusions without a Subject

However, as soon as one makes the illusion at work in the situation explicit ('Hey, you are acting as if . . .'), the civilised will immediately be able to recognise the illusion as an illusion, just as well as the savage does. For neither think that representations of killing or reading are the same as killing or reading. They do not believe in the equivalence between the symbol and the symbolised. As Ludwig Wittgenstein pointed out, this lack of belief is a fundamental condition for practising magic. Those who practise magic always clearly distinguish these magic practices from real, technical measures, and they distinguish between situations in which they apply the ones or the others.[3]

Magic thus presupposes that the magician does not take a symbolic act for real. In the case where someone does that, if they take a purely symbolic act for a real act, they succumb to an illusion, but they do not practise magic. If, for example, I am at a football match and shout to a player who is too busy or too far away to hear me, I may believe in an illusion of communication, but I am not practising magic. If, on the contrary, at home I shout at a football player on television, I do not at all believe that he can hear me, but I do practise magic. The recognition of the purely symbolic character of the magic practices is indicated by the shamefulness with which they are usually performed. This symbolic dimension is also designated by their practitioners – strangely – through remarks such as 'this does not mean anything'.

The illusion at stake in the practices of interpassivity therefore has a very interesting and particular kind of ownership: it is in a way *nobody's illusion*, an *anonymous illusion*, an *illusion without a subject*.[4] None of the real people present at this little spectacle (and, in our photocopying example, the copying intellectual is

often the only person present) has to believe in this illusion. The possibility of delegated reading does not depend on the presence of a believer, since it is not just a subjective illusion: delegation works for the intellectuals not because *they* think that the machine can read for them; the machine reads for them because *somebody else*, an anonymous naive observer, might have thought that.[5] In this sense, the anonymous illusion is an *'objective' illusion*. The interpassive act of photocopying is an act that takes place, as it were, *in the medium of the others' illusion*. Therefore, when Žižek wrote regarding TV sitcoms that 'objectively, through the medium of the other, we had a really good time', this not only referred to the objectivity attained by the 'reification' of our amusement in the canned laughter; it also pointed to the objectivity of the illusion at work in the situation.

7 The Interpassivity of Rituals

With the help of an objective, anonymous illusion we can interpassively delegate all our pleasures and acts of consumption (laughing, reading, eating, drinking, etc.) to an interpassive medium. Somebody else – an anonymous other, not us – believes, then, in the equivalence and thinks that we were enjoying; and this anonymous belief in our enjoyment brings about the deep satisfaction that we experience when we never watch our video tapes.

This structure also applies to religious belief. Religious belief, too, can become subject to interpassive practice. We do not have to believe, then, ourselves (and consume, as it were, the 'comforts of religion'), but some anonymous other merely has to be made to believe that we believed. Thanks to an anonymous

illusion we are therefore able to derive a lot of satisfaction from not believing in our own religion.

The anonymous belief that allows us not to believe is established through performing the ritual. This objective illusion is at work in almost all ritual religious practices. Therefore we can say *that there exists a profound interpassivity of the ritual as such.* Through rituals, individuals delegate their religious beliefs to interpassive media. Not only is interpassivity based on ritual, but the ritual itself is based on interpassivity. This has been pointed out by Slavoj Žižek with regard to the use of Tibetan prayer wheels. Žižek describes this practice as follows:

> you write a prayer on a paper, put the rolled paper into a wheel, and turn it automatically, without thinking [. . .] In this way, the wheel itself is praying for me, instead of me – or, more precisely, I myself am praying through the medium of the wheel. The beauty of it all is that in my psychological interiority I can think about whatever I want, I can yield to the most dirty and obscene fantasies, and it does not matter because – to use a good old Stalinist expression – whatever I am thinking, *objectively* I am praying. (Žižek 1997: 35)

By staging an objective illusion, with the help of the religious interpassive medium of the prayer wheel, the Tibetan can distance himself psychically from his religion. Yet this interpassive dimension does not only appear in special or even exotic religions. We can find the same, for example, within Christianity: a Christian believer may go to a church, burn a candle, stay for a few minutes and then leave the church while the candle remains in his or her place, burning for a few more hours. The formula 'Ora pro nobis' – read in the sense of '*Pray instead of us*' – seems to be the key for understanding the interpassive dimension inherent in ritual action.

By acting 'as if' praying would take place, the Tibetan and the Christian actually keep a distance from their religion – just as the interpassive video freak evades watching television. The Tibetan's and the Christian's ritual practices thus turn out to be defensive moves against their proper religions. They allow the Tibetan and the Christian to indulge in a psychic or spatial 'disappearance' (be it into obscene fantasies, as in Žižek's example, or a change of space and practice, as in the case of the Christian).[6]

Disappearance becomes possible through performing a ritual, that is, by offering a spectacle designed for an objective, anonymous belief. The objective belief that is at work in ritual renders superfluous the 'subjective', personal belief of the religious believer. When objective belief is there (thanks to a ritual medium), the religious subject can go away. As a result of its interpassive dimension, the ritual frees the individuals from subjectivisation.[7] This is what Žižek has called '*the beauty of it*'.

8 Religion and Religious Hostility against Ritual

The fact that religious rituals have this interpassive dimension, allowing believers to keep a distance from their religious belief, is very well illustrated by the history of religions. It is reflected in a constant hostility of religions towards their own rituals. Far from conceiving their rituals in a benevolent Pascalian way[8] as necessary and reliable means of religious practice and propaganda, religions often regard their own rituals with deep suspicion and even adopt active measures against them. Humphrey and Laidlaw have commented on this very pointedly:

> What happens in religious traditions when the nature of ritual is questioned, but the practice of performing rituals is not itself

abandoned? Much anthropological analysis simply equates religion and ritual, or regards them as forming some kind of indissoluble whole, yet in many cases a religious attitude, a searching for spiritual perfection perhaps, can turn upon its own vehicle, ritual, to regard it with distrust, deprecation, or even fear. [. . .] We think that these reactions to ritual tell us about more than just particular religious ideologies, for there is a sense in which, when different religious traditions act in this way, they are reacting to a common phenomenon. Such reactions therefore reveal the essential features of ritual action. (Humphrey and Laidlaw 1994: 1)

This 'deprecation' of ritual by its own religion often leads to practical consequences. As Sigmund Freud noted, the history of every religion is characterised by constant returning 'leaps of reform' (Freud [1907]: 126) – by attempts to reduce the obser-vance of allegedly 'meaningless' rituals and to replace them with conscious attention to meaning. *Reform* always turns against *form*. The use of ritual machinery and of specialists (priests) becomes more and more reduced in religious ideology (unlike the economy, where the use of machinery and division of labour increase across history). An increasing imperative of 'Do it yourself' characterises the history of religion. The exteriority of ritual is thus transformed into the interiority of religious con-sciousness, as can be seen for example in the 'leap' that led, in Christian religion, from Catholicism to Protestantism. Clearly this hostility of religions towards their own rituals expresses an acknowledgement of the fact that the rituals allow the believers to avoid conscious attention to the religious meaning. When religions abandon a good part of their own rituals, they try to destroy the interpassivity inherent in those rituals.

The 'leaps of reform' within the history of religion show a tendency to replace ritual interpassivity with the religious

consciousness of individuals. Anonymous, objective *belief* is erased in order to establish subjective *faith* (see Mannoni 1985a: 13). Non-subjectivised forms of religion become more and more 'superstructured' by subjectivised forms. Of course, this process has its limits: ritual can never be completely abandoned; an 'invisible religion', as conceived by David Hume, is not possible (or rather, it is not a religion any more) (Hume 1907; Bozovic 2000: 3–14). The religious superstructure of subjectivised faith can never completely replace its basis, the anonymous, objective belief embodied in ritual.

9 Civilised Blindness

The only thing that these 'leaps of reform' can do is to render the interpassive dimension of religion more and more invisible. The existence of objective belief cannot be abandoned, but only its visibility. This is the reason why civilised people, as opposed to 'savages', are unable to recognise that they are practising magic.

Now, this increasing subjectivisation not only creates blindness to the magic dimensions in civilised culture (for example, when people speak to their cars, as if thus they could encourage the engine to start). Since objective belief is the basic principle of cultural pleasure,[9] *blindness to objective belief also implies an unawareness of one's own pleasure.* 'Civilised' cultures, blind to their magic dimensions, are therefore unable to consciously enjoy their pleasures. The remarkable rise in ascetic ideals within Western culture during the last decades expresses an increasing inability to deal with cultural pleasure. Throwing little children in jail for playing 'doctor games',[10] spending huge amounts of

government money on campaigns to prevent young people from having pre-marital sex, demonising and disenfranchising simple pleasures such as drinking and smoking are just the most striking examples of this growing asceticism. A general tendency towards a 'culture of complaint' (cf. Hughes 1993) gives proof of the fact that the so-called 'civilised' are increasingly unable to experience their own pleasure as a pleasure. Instead, they can only experience it in its reverse form, as 'neurotic displeasure', as Freud has called it. Pleasure that passes unrecognised returns as its opposite. What cries of joy are for those who know how to enjoy, sighs of complaint are for those who don't.

10 Ritualism without Primitivism

From here we can see what is at stake concerning ritual: what the key thesis of the 'ritualists' about the 'precedence of ritual' really says is that objective belief ('ritual') comes before subjective faith ('myth'). This implies *that objective belief can stand alone*, without being covered up by subjectivisations that render pleasure invisible and thus unpleasant.

We have to add that this applies not only to so-called primitive societies where ritual appears not to be accompanied by myth. It also applies, for example, to ancient Greek culture – which, of course, was full of myths, but not of myths that allowed for subjectivisation. This can be seen in the mythological element of the 'bad gods': the fact that, in Greek mythology, gods behaved more badly than men gives clear proof of the fact that this mythology did not create any possibility for individuals to 'recognise' themselves as subjects in any big SUBJECT.[11] This is the reason why Greek culture developed a completely different

relationship to both guilt (as Nietzsche remarked [1984: 280–1]) and pleasure (as Freud stated [1905b: 150]).

What is at stake in the thesis of the ritualists is therefore not the 'primitivism' that consists in a lack of mythology. Rather, it is the idea that even in so-called 'high' cultures, the social imaginary can be organised in a different way. Objective, 'interpassive' belief can stand for itself. And such an organisation of the social imaginary is not a mark of primitive societies, but rather a mark of culture. Because – as Freud remarked – what could merit the name of culture if not the ability to create and to get along with one's pleasure?[12]

This is the reading that we have tried to give to the thesis of the ritualists by applying the theoretical tool of our concept of interpassivity: stating that ritual comes before myth means that high cultures are able to avoid the barbarism of succumbing to ascetic ideals.

Notes

1 This highly problematic equation of *observation* with *passivity* which is presupposed by the notion of interactivity has been criticised by Harold Bloom (Bloom 2000).

2 The classical formulation of this problem was given by Ludwig Wittgenstein, when he asked whether one could feel pain in a part of somebody else's body: '*Es ist offenbar vorstellbar, daß ich einen Schmerz in der Hand eines anderen Körpers als meines sogenannten eigenen spüre. Wie aber, wenn nun mein alter Körper ganz unempfindlich und unbeweglich würde und ich meine Schmerzen nur mehr im anderen Körper empfände?*' (Wittgenstein 1981: 90 §60) ('It is clearly imaginable that I should feel a pain in the hand of a different body from the one called my own. But suppose now that my old body were to become completely insensible and inert and from then on I only felt my pains in the other body?' [Wittgenstein 1975: 90]).

3 Cf. Wittgenstein 1993a: 125: 'The same savage, who stabs the picture of his enemy apparently in order to kill him, really builds his hut out of wood and carves his arrow skilfully and not in effigy.'

4 Mario Perniola has elaborated on the idea of a *sensation* that does not belong to anybody (Perniola 1999: 9, 167). What we encounter here is an *illusion* that does not belong to anybody.

5 For a theory of this 'anonymous' belief, see Mannoni 2003; for a comparison between the naive observer and other psychic instances of self-observation (superego, ego-ideal), cf. Pfaller 2014: ch. 9.

6 For this notion of disappearance, see Virilio 1980.

7 This rule does not only apply to interpassivity within religions; it is at work in all kinds of interpassivity. Since, according to Althusser, subjectivisation is achieved through interpellation (cf. Althusser 1971: 110), we can say that *interpassivity is opposed to interpellation*. The possibility of avoiding subjectivisation appears to be the reason for interpassive practice, and the key source of the strange satisfaction experienced by interpassive individuals.

8 Cf. Pascal 1995: 125 §418: 'You want to be cured of unbelief and you ask for the remedy: learn from those who were once bound like you and who now wager all they have [. . .]: follow the way by which they began. They behaved just as if they did believe, taking holy water, having masses said, and so on.'

9 This can clearly be seen in the specific pleasure provided by *trompe-l'œil* paintings, where you have, for example, the painting of a landscape together with an illusion that the painting is covered by broken glass. Of course, the pleasure of this refinement is only accessible to those who discern the 'broken glass' as an illusion, as a part of the painting. If, on the contrary, there are observers who succumb to this illusion, unable to delegate it to anonymous others, they cannot experience the pleasure. For them it will remain simply regrettable damage, a mundane reality. Only those able to delegate the illusion (for example, by saying '*somebody might have thought* the glass was broken') can experience the pleasure provided by the artwork. (I have elaborated this in my book *On the Pleasure Principle in Culture. Illusions without Owners* [Pfaller 2014]).

10 See the notorious case of 11-year-old Raoul Wütherich, http://www.nytimes.com/1999/11/12/news/judge-dismisses-incest-case-against-swiss-boy-of-11.html (last accessed 16 December 2016).

11 The imaginary recognition of the individual as a subject in the image provided by a big SUBJECT is, according to Althusser, the key structure of subjectivisation (Althusser 1971: 120).

12 Cf. Freud [1908]: 32. This is the reason why Freud, in his title 'Die "kulturelle" Sexualmoral . . .', puts the word 'kulturelle' in quotation marks: when a culture is unable to produce individual happiness, its imperatives no longer merit the description 'cultural'.

4

Interpassivity and Misdemeanours:
The Art of Thinking in Examples and
the Žižekian Toolbox

1 Materialism in Philosophy and the Role of the Example

A significant characteristic of Slavoj Žižek's theory jumps immediately to the eye of any reader of his writings: Žižek's theory is a philosophy that proceeds through examples. This philosophy has its turning points and finds its crucial highlights in elements such as the Rabinovitch jokes, the Hitchcockian McGuffin or the obscenities exchanged between soldiers of the former Yugoslav people's army. Since this art of thinking in examples is one of the key requirements of interpassivity theory, as well as one of the constant points of philosophical disagreement with regard to Žižek's theory, I want to present in the following a few considerations about the characteristic features and the specific stakes of this method.

My first claim here is that proceeding through examples in philosophy is a necessary, ever-present *mark of materialism*. Žižek's way of proceeding has to be compared with those pertaining to the great materialist tradition in philosophy: with the methods of philosophers such as Epicurus, Spinoza, Pascal, Marx, Freud, Wittgenstein, Althusser and − not to forget − Lacan. Yet, as Ferdinand de Saussure (another materialist, with

great examples) remarked, it is always easier to find a certain truth than to assign it to the right place (Saussure 1987: 100). The truth that materialism in philosophy necessarily proceeds through examples does not explain why this is necessary and what the role of the example is.

A first catch here may be the idea that the example stands for the particular, as opposed to the general, and that the role of the example is to illustrate the general idea that it exemplifies. From this idea one could be inclined to draw the conclusion that materialism would, by its nature, always take the side of the particular, as opposed to the general. This would bring materialism close to nominalism or empiricism; yet, as materialist philosophers such as Louis Althusser have proved, empiricism is not necessarily materialist; it can be precisely its opposite. (Empiricism, according to Althusser, often presupposes the idea that the real explains itself; that there are no theoretical tools and no theoretical operations necessary in order to gain knowledge from the raw material of theoretical practice [cf. Althusser 1990: 226].)

Yet not only the conclusion is misleading here; the first concept of the example as a concrete illustration of an abstract idea is completely wrong with regard to Žižek. In Žižek's theory, the example fulfils a completely different function. In order to sum up this very special, paradoxical function of the example in Žižek's theory, one may recall here the structure of the well-known 'Radio Erewan' jokes that Žižek sometimes refers to, and ask: 'Was Žižek's example a concrete element that illustrated an abstract idea presented before?' Radio Erewan would then answer: 'In principle: Yes. But, first, the idea was not totally abstract, second, the example was not more concrete than the idea, and, third, what the example did to the idea was not to illustrate it at all.'

2 What Žižek Does with Examples: An Example

Let us look, for instance, at one of Žižek's classics, one of his most brilliant passages, and one that has been of crucial importance for the discovery of interpassivity (see Pfaller 2014: 15–34): the development of thoughts concerning the 'objectivity of belief' (cf. Žižek 1997: 33–5). Starting from Marx's formulation of commodity fetishism, Žižek directs his argument along a chain of connected examples: the Tibetan prayer wheel; the Lacanian interpretation of the role of the Chorus in Greek tragedy; the function of 'canned laughter' in contemporary TV sitcoms; the joke about the fool and his fear of being a grain for a hen.

First, it has to be stated that the idea that Žižek in his elaboration points to is far from being there at the beginning. Marx's theory of commodity fetishism does not include this idea at all. On the contrary, Žižek uses his first example, the Tibetan prayer wheel, in order to dismiss the idea usually connected with Marx's formulation – the common understanding of it as an argument situated at the level of *economy*, the humanist criticism of economic relations in capitalism ('we have become the objects of our objects'). Instead, Žižek suggests that Marx's argument be read not as an economic criticism but as a theory of *ideology* – yet in a sense in which ideology has hardly ever been conceived of; not in the Marxist tradition, and not outside of it. The theoretical twist, the new meaning that Žižek, with the help of Tibetan prayer wheels, gives to Marx's formulation, is that things are able to believe instead of us.

It has to be remarked, however, that even this second element, the Tibetan prayer wheel, is far from containing the new idea clearly and without ambiguity. The idea that religious people in Tibet might indulge in obscene fantasies while 'objectively'

praying through their ritual instruments is one that European theorists have hardly dared to conceive of (despite some statements by the Dalai Lama which appear to testify to the paradoxical 'detached' status of this ritual practice)[1] – by reasons of intercultural respect alone. Therefore, in a third step, a new example, with conceptual support from Lacanian theory, has to be introduced: Lacan's idea that our most intimate feelings, beliefs and convictions can assume an 'external existence', and that the Chorus in Greek tragedy had precisely such a function (cf. Lacan 1986: 295): to feel fear and compassion vicariously, on behalf of the spectators. Yet, again, Lacan's idea may appear as an audacious, highly speculative and arbitrary interpretation with little empirical support and even less plausibility. It is no wonder, then, that this passage in Lacan has for a long time passed unnoticed; nobody has made any use of it or referred to it, not even within Lacanian theory.

It is here that, in a fourth step, Žižek makes Lacan's historical assumption for the first time clear, plausible and justified by connecting it with an example from our own contemporary culture. The phenomenon of canned laughter on television (connected with the observation that we usually do not laugh when this laughter appears) allows Žižek to give full credibility and concreteness to the idea of Lacan which had until then remained a kind of theoretical 'sleeper'. Žižek's merit here is considerable: just as in ethnology, so in this case, an element belonging to another culture is not understandable so long as we are unable to overcome our strange blindness to its precise counterpart in our familiar context. The Greek Chorus remains an enigma as long as canned laughter is treated as perfectly normal. Only by 'estranging' and problematising our own practice, that is, by recognising its strangeness and by transforming its previous

evidence into a question, do we get a key for replacing our astonishment and our assumptions about foreign phenomena with theoretical concepts. (Ludwig Wittgenstein proceeded in the same way when, in his critical objections against Frazer's theory of 'savage' magic, he pointed out that there exists a magic of the 'civilised', and that precisely this 'civilised' magic, which is not based in magic assumptions or convictions, has to be taken as the model for understanding its counterpart in foreign cultures. Cf. Wittgenstein 1993a: 140, 124).

By adding a fifth element, the fool–hen joke, Žižek finally points out the remarkable power our beliefs assume once we have delegated them to things: delegating one's beliefs makes them even stronger than they were before. Believing 'objectively', through external objects or vicarious agents, does not provide any release from the constraints exerted by our beliefs; on the contrary, as soon as we have transferred these beliefs on to external agents, they become 'ontologically' relevant. Now these illusions determine the objectivity of the outer world, thus transforming our 'enlightened' knowledge about how this world 'really' is into a purely subjective abstraction. This reinforced status of the illusion, precisely through 'detachment', better knowledge and delegation on to things, is the reason why, as Žižek points out, laughter and ironical distance are far from helping us out of ideology (as Umberto Eco had assumed; cf. Žižek 1997: 27) and why, after the 'end of all narrations' and the arrival of 'cynical reason' in postmodernity, we are far from being post–ideological.[2]

3 The Bending of the Stick

As can be seen in this sequence of theoretical steps, performed through certain crucial examples, there is no initial 'abstract' idea that becomes 'illustrated' by a 'concrete' element. If there is an abstract idea at all (for example, a first Marxist concept of fetishism), then the example presents another abstract idea (a different Marxist concept of fetishism). Yet what the example in Žižek's texts usually refers to is in itself already another example, another concrete element. Žižek proceeds by connecting one concrete element with another: for example, 'canned laughter' in TV with Lacan's idea of the role of the Chorus in Greek tragedy.

The function of the example is therefore not to illustrate or to exemplify its – in most cases equally illustrative and exemplary – counterpart, but to displace it; to drag it away from its initial position; to 'estrange' it (in the sense of Bertolt Brecht); to shed a different light on it; to comb it against the nap, as it were – in other words to interpret it, against its common understanding and against its self-understanding (this is the violent sense that Nietzsche gives to the notion of 'interpretation').[3]

This is why, according to Žižek, 'One example is enough'[4] – that is, to accomplish such a theoretical move. In Žižek's texts, the example is not there in order to give 'inductive' plausibility to an idea (by enumerating several of its instances) or to illustrate what can be seen in the exemplified; on the contrary, the example is there in order to take away the idea's plausibility and to make visible what, at first, could not be seen in it. Instead of being an *illustration of an idea*, the Žižek example is rather a *caricature of another example* – and a criticism of the idea usually connected with that example. Žižek's examples comment upon each other;[5] therefore they seem to function like the 'myths' of

73

which Lévi-Strauss remarked that one myth can function as the interpretation of the other.

The typical Žižek example does not present an instance to which an abstract idea could be easily applied. It is not a *passive* material that visualises something that has already been *included* in the abstract idea. Its function is rather to make something appear that was completely *foreign* to the first idea, and to which this idea could only be connected through considerable theoretical effort. The example is therefore highly *active*. It is not just the object or the raw material of a theoretical explanation, but it functions as its theoretical *tool*: it makes visible a theoretical structure in the original idea which, before, was not easy to discern or which was even hidden by another structure that appeared evident. Due to its active nature, there is a certain *retroactive force* proper to a Žižek example: after you have heard the example, you can perceive something in the exemplified element that you were not able to see before. Yet after having heard Žižek's example, it is probably difficult to understand the exemplified ever again in the same way that you had understood it before.

For example, when Žižek uses the joke about Rabinovitch's two reasons for emigration to explain the structure of Hegelian dialectics, he makes clear that, in Hegel, the antithesis is in itself already the synthesis, yet seen from another perspective.[6] This had never been visible or clear to me before I came upon Žižek's example. Yet now I can hardly think of Hegelian dialectics without conceiving it like this and recalling Rabinovitch's *chuzpe* as well as Žižek's brilliant idea of connecting it with Hegel's dialectics.

One could say here that, precisely by using the example, Žižek makes clear that what appeared as the 'idea' of Hegelian dialectics

(just as in the case before of the idea of Marxian commodity fetishism) had actually not been an idea *but an example in itself*, since what Žižek's example makes visible had not been visible in the idea itself. (And what is an idea if not something in which, by its very name, the visible should be visible?) Žižek's example therefore *decentres* a presumed idea; it refuses its claims for universality and self-transparency and reveals its true nature, which is that of another example.

Just as psychoanalysis, according to Freud, makes the analysand say what he does not know,[7] the Žižek example makes another thing say *what, until then, it did not know*. A Žižek example is not just a particular instance of a general concept or law under which it can be subsumed. The example is not there in order to match an abstract description or concept. Finding an example is therefore not a matter of *judgement*, as in Kant.[8] Rather, this requires a kind of *witty philosophical refractoriness*: the ability to discover a given phenomenon's power to contradict a previous idea that we had about another phenomenon. The use of examples becomes here what Gilles Deleuze calls a 'concatenation' (cf. Deleuze and Parnet 1996: 65): example and exemplified can be connected because they are logically equal elements dwelling on the same level of generality. Yet the example has the advantage of coming later, and thus has the chance to work upon the previous element, to transform it. Or, to put it in Lacanian terminology: the example is a master-signifier which retroactively gives a new interpretation to a previous signifier.

What Wittgenstein describes as the role of the 'picture' in his philosophy applies therefore to Žižek's examples. Wittgenstein's pictures change the previous understanding one had about a certain case:

> I wanted to put that picture before him, and his *acceptance* of the picture consists in his now being inclined to regard a given case differently: that is, to compare it with *this* rather than *that* set of pictures. I have changed his *way of looking at things*. (Wittgenstein 1967: 57e §144)

Wittgenstein's pictures are there in order to change a previous understanding, an understanding that had, itself, already been determined by certain other (perhaps unacknowledged) pictures. Therefore Wittgenstein's pictures do not give an illustration where there was nothing (or only abstract ideas) before; rather, they are *counter-pictures*. They break with previous pictures; they destroy a previous understanding that, due to the imaginary power of unquestioned pictures, had presented itself as self-evident. The Wittgensteinian picture has its crucial moment precisely when another picture 'holds us captive' (cf. Wittgenstein 1967: 48e §115).[9]

Here we find the reason *why materialist philosophy cannot do without pictures*: in order to break free from the imaginary captivity in which we are held by certain images, we need other images, counter-images; since, as Spinoza stated, something can only be limited by something else which is of the same nature (Spinoza 1955: 45).

Such a concept of the theoretical space is thoroughly materialist: it conceives it as a field not just of ideas but of pictures that hold us captive, of evidence that blinds us, of considerable forces that keep us down; and of other forces that have to be developed: counter-forces, able to break with the former. Louis Althusser has formulated this materialist idea of the theoretical space, using another example – that of the bending of the stick:

> It follows that if you want to change historically existing ideas, even in the apparently abstract domain called philosophy, you

cannot content yourself with simply preaching the naked truth, and waiting for its anatomical obviousness to 'enlighten' minds, as our eighteenth-century ancestors used to say: you are forced, since you want to force a change in ideas, to recognize the force which is keeping them bent, by applying a counterforce capable of destroying this power and bending the stick in the opposite direction so as to put the ideas right. (Althusser 1990: 210)

This idea that the theoretical space is such a physical field of forces did not, by the way, stem from philosophical speculation. It was developed by one of Althusser's teachers, the scholar of the history of sciences Gaston Bachelard. Investigating the history of sciences such as physics, chemistry and mathematics, Bachelard found out that a science, in order to establish itself, has not simply to find some knowledge where previously there had been none, but to break with previous, spontaneous evidence, with 'epistemological obstacles' that keep the theoretical space of this very science blocked from the outset.

This is important to mention since it refers to a fundamental epistemological problem pointed out by Bachelard – a problem that can be called the problem of the *initial narcissism of theories*. When a theory does not succeed in breaking with the first spontaneous evidences provided by sources such as common sense, then it does not even have an object. Whenever such a theory thinks to speak of an object, it speaks in fact about nothing but itself. What a theory 'sees' when it actually sees nothing, is itself – that is, its own expectations, presuppositions and prejudices. As Bachelard puts it,

It suffices us to speak about an object to make us believe that we are objective. But, through our first choice, the object rather designates us, than us designating it, and what we consider our

fundamental ideas of the world, often are nothing but confidential revelations about the youthfulness of our spirit. (Bachelard 1974: 134; trans. Astrid Hager and Robert Pfaller)

Breaking with the first evidences of common sense is necessary for any theory in order to obtain an object. Before being able to say something right or wrong about an object, a theory has to leave that starting zone in which nothing is either right or wrong and where it speaks about nothing but itself.

Providing science with an object, and breaking with its inevitable initial narcissism, is a thoroughly materialist task. This is not only so because in the history of philosophy many schools that called themselves materialist have stressed the importance, or even the primacy, of the object. There is a much more systematic reason for this (since materialism is, in the first place, not a theory of cognition). Following psychoanalytic theory (see especially Grunberger and Dessuant 1997), we can say *that the secret, yet most general name for philosophical idealism is narcissism*. In today's culture we can discern this narcissism in the underlying philosophical matrix that governs many discourses, creating the typical preferences of these very discourses: for example, a preference for being a subject instead of being an object; a preference for what is constructed as opposed to what is seen as essential; a hymnic hailing of 'immaterial work' (for example by Maurizio Lazzarato [1998: 40] as well as by Hardt and Negri [2002: 305]); and, correspondingly, a fundamental distrust in materiality (for example, in art, be it physical materiality or the materiality of a determinate form that cannot be 'interactively' altered or arbitrarily interpreted); distrust in the materiality of political and ideological apparatuses, neglect of the question of political organisation, etc.

The fundamental philosophical disease of our time can therefore be seen in these spontaneous choices that are made

without awareness of their underlying idealism and narcissism. As Richard Sennett noted in 1974, this narcissistic attitude can be summed up in the formula 'Be yourself! And do not tolerate anything that appears foreign to your precious self.' Today, under neoliberal conditions, it can be seen how this categorical imperative of our culture leads to most affirmative forms of pseudo-emancipatory politics, and even of self-exploitation.

As opposed to this, proceeding through examples the way Žižek does means breaking with the first narcissistic evidences of theory to allow theory to accede to an object, and to recognise the materiality of the theoretical space. As a consequence, this points to a crucial philosophical perspective: not to seek one's freedom beyond the sphere of materiality.

4 The Filthy Examples and the Beautiful Souls

Žižek's examples constantly show a surprising aptitude to break with given evidence. This is, to my view, what constitutes one of Žižek's greatest merits in philosophy: the proof of his amazing ability to discover a certain theoretical structure, a transformative force, in a given element – in any element that culture can provide. Like the proverbial wise man, Žižek is able to learn something from everybody and everything. Nothing is too stupid or too trivial to teach him something – that is probably the best thing one can say about a philosophical intellect. This means also, in the first place, that nothing human is foreign to Žižek; no existing phenomenon is able to challenge his theories as a naive, blue-eyed idealist dream. Whereas other philosophers' ideas (for instance, Habermas's concept of non-hierarchical communication) appear funny the moment that you try to imagine

them relative not just to ordinary petty-bourgeois Western academics, but, for example, to equally Western sadomasochist leather-gays, Žižek's theory appears able to face any particular challenge exerted by an existing practice – no matter how strange, kinky, awkward, dirty or cruel it might appear.

Again, this is not self-evident – and least of all in contemporary culture. Are we not surrounded by 'beautiful souls' who do not allow themselves (or others) the use of bad words or thoughts? Is cultural theory today not totally subverted by a 'childhood disease' that, at any price, tries to stay away from 'adult language' as well as from the realities that this language designates? (We should not forget here that *the* childhood disease, according to psychoanalysis, is [secondary] narcissism.) Is there not a sort of 'enlightenment' and 'pure reason' in power that does not hesitate to call for the police – or even tries to become that police – in order to prevent itself from acknowledging 'filthy' matters? The problem is, of course, that, in the last instance, narcissism by its very nature perceives every matter as filthy (cf. Grunberger and Dessuant 1997: 203) (since matter represents the symbolic order which, by its rules and laws, puts constraints upon the 'pure' narcissistic ego). As opposed to this, we should remind ourselves that materialism in history has always revealed itself by its dirty, sarcastic way of speaking. Ancient authors such as Chrysippos, Diogenes and Epictetus, and their modern counterparts such as Spinoza, Mandeville, Marx or Brecht, have taught us lessons of sarcastic laughter with regard to unpleasant realities. These authors have not hesitated to play the role of the black sheep, of the *bête noire* that speaks out the dirty truth that nobody wants to acknowledge or to take into his own mouth.

Against the background of contemporary 'newspeak', the presumptuous cleanliness that characterises today's academic and

non-academic theorists and police officers of discourse, Slavoj Žižek has taken a unique stance. Here in particular it becomes clearly visible that his examples function in order to brush something against its grain. In his choice of subjects, matters and ways of speaking, Žižek has never cared whether he himself would appear advantageously pure or virtuous. Following the 'plebeian' tradition of philosophical materialism (cf. Žižek 1997: 29), he did not hesitate to speak of bad things, and he called things by their names – preferably by their worst names, since only this can prevent theory from painting reality pink and becoming an idealist, 'apologetic' narrative. 'The cleaner you are, the dirtier you are' is the rule one could hear Žižek say sometimes. This position can be reformulated in Lacanian terms: if there is any chance to show respect or decency under respectless and indecent conditions, then this chance is not to be looked for on the level of the *enunciated content*. The level of *enunciation* alone – the fact that things are actually called by their names – is the only level where a utopian wish can inscribe itself without becoming immediately ideological: the wish that things might become better than their spoken names.

As a consequence, Žižek's discourse has never shown the least attempt to appear 'politically correct'. As opposed to that, most contemporary theorists as well as artists constantly seek in a narcissistic way to look good when they speak about certain things (and keep silent about others). Yet this non-dialectical way of proceeding leaves no room to move for their listeners. The latter can do no more than agree with what has been stated ('Yes, the author is right, this minority really is in a deplorable situation'). This keeps the audience in a totally resigned, yet at the same time presumptuously satisfied, position ('we are on the good side').

Unlike Rabinovitch, contemporary politically correct authors do not have 'a second reason' when they speak. They never start speaking ironically or sarcastically from a position opposed to what they mean in order to trigger a movement of thoughts, affects and responses in their audience. Therefore this discourse produces nothing but the tacit satisfaction of the bourgeois classes that they are not to blame for the bad state of affairs in the world (which they, according to an obscene aesthetics of the sublime, love to observe through a safe theory or art space). Žižek, on the contrary, has never followed this pattern. He willingly assumes the role of the *bête noire*. With regard to this gesture of his, we may be reminded of Nietzsche's remark about the nobility of the Greek gods who did not execute punishment but rather, more elegantly, assumed guilt themselves.[10]

A constant awareness of the 'extremes' pushes Žižek's thought forward and allows him to take his 'impossible' positions which are necessary in order to render theoretical thought possible (see Althusser 1990: 209). This non-naivety of Žižek is a proper materialist stance. Louis Althusser coined for this stance a formula which he called 'the only definition of materialism': *'not to tell oneself stories'* ('ne pas se raconter d'histoire', Althusser 1994: 247). Precisely by his examples, which are often stories, Žižek succeeds in preventing his philosophy from becoming a story.[11]

5 Dirty Matters as Sharp Tools

This theoretical familiarity with all kinds of realities, remote as they may be from academic life or horizons, allows Žižek to build up that unique field of theoretical operation that characterises

his work. As many observers have remarked, the most hetero-geneous realities become part of Žižek's theory. From *The Matrix* to Marx, from one balls joke to another, from fistfucking to the Flintstones, from CIA torture to children's toys, from Coca-Cola commercials to Communist Party secrets – nothing is too high or too low to be excluded from the scope of his philosophy. This creates an extremely egalitarian atmosphere in Žižek's approach.

Yet this egalitarian spirit does not stem only from the fact that these mass culture elements are allowed to enter into 'highbrow' philosophy (as they were before, for example in Walter Benjamin, Roland Barthes or Umberto Eco). What makes Žižek's proceed-ing so egalitarian is the fact that these elements are not just there, but that they are also regarded, by Žižek, as equally apt to serve him as theoretical tools – as 'synthetic a prioris', as it were. The commercial is not just there in order to be analysed by elaborated theoretical means; on the contrary, it may very well be used to analyse a given theory, as its object. And the artwork is not just there as a more or less enigmatic raw material to be interpreted by refined psychoanalytic devices; on the contrary, Hitchcock may become the theoretical tool and tell you what you always wanted to know about Lacan (but did not dare to ask).

The example is elevated to the dignity of a theoretical tool: this is what distinguishes Žižek's theory from many efforts in contemporary cultural studies which appear equally close to their respective realities. Yet cultural studies today often lacks distance from its material. It feels most adequate when it gets completely immersed in its object, the cultural or subcultural reality it describes. Žižek, on the contrary, never enters into the same intimacy with the elements he uses. Being taken as theoretical tools, the examples help him to get a distance from the self-understanding of the reality he deals with. This

corresponds to what Louis Althusser once called the 'Golden Rule' of materialism: 'Do not judge a given reality according to its self-understanding.'[12]

This may also explain why Žižek appears to show little love for his cultural objects. He uses mainstream Hollywood movies, but rarely refined or extravagant productions. He refers to novels, but, as has been remarked, almost never to lyrics.[13] Yet Žižek's theory is not film theory, but theory that works with film; not theory of literature, but theory that works with literature; not theory of everyday culture including its dark sides, but theory that works with phenomena from everyday culture including its dark sides. Precisely because his cultural objects serve him as tools, Žižek does not make his choices according to their refinement and cultural value, but according to their explanatory and interpretative value.

Therefore Žižek's way of dealing with examples is not the kind of sympathetic, orbiting meditation about certain phenomena that essayists such as Walter Benjamin, Roland Barthes, John Berger or Stephen Greenblatt have presented. Žižek takes his objects directly and with force, like a hammer, in order to strike against an epistemological obstacle, and he does not care about the hammer's colour, history, provenance, inscription and so on. More refined objects would not serve him so well in the role of such a tool, and so Žižek obviously hesitates to use them – and, if we remember Kant, it is not the worst one can do if one hesitates to use somebody 'just as an instrument' (Kant 1974: 61).

The frequently made observation that Žižek completely 'flattens' out his examples is not wrong here.[14] Yet one has to remember their status as theoretical tools. In the field of theoretical vision, one has to make a choice: either the object is what you look at, or the object serves you as a lens through

which you look at something else. And if it serves as your lens, then you do not have to care for the variety of its qualities, but for one quality alone: its ability to sharpen your view of something else. In the good Spinozan tradition of producing optical lenses, Žižek sharpens the 'definition' of his examples in order to get a sharp view of another object. Only in a second step may one reverse this setting. What has been, until then, the object of elaboration can then become its instrument and serve to treat the former instrument as an object. A lensmaker, for example, wearing his glasses, can make new glasses by which he, later, can sharpen his old ones. (This is the way in which, for example, Freud proceeds when, in his essay 'Obsessive Actions and Religious Practices' [Freud 1907], he first uses religion in order to make obsessional neurosis understandable and then, reversing this explicative relationship, sheds new light on the dynamics in the history of religion with the help of his insights into obsessional neurosis.)

Since Žižek's examples are his tools, one has to learn his examples in order to understand him. It is not enough just to know them; one has to be able to have them present in the toolbox and to master them skilfully; one has to be able to remember quickly how and where they have to be applied in order to produce an unexpected insight. This is the way in which the ancient philosophers such as the Pyrrhonean sceptics or the Kynics exercised their examples (which they called their 'tropes'). Hence they were so fit and quick to refer to the examples of dogs or noble Persians in order to dissipate imaginary formations such as the tragic lure of the Oedipus myth – by stating sarcastically, for example, that creating children with one's mother need not necessarily be regarded as such a bad thing (cf. Hossenfelder 1996: 29).

At this point, it can easily be shown why a recurrent objection against Žižek's examples is beside the point. One often reads, first, that Žižek shifts too quickly from one example to another and, secondly, that he often repeats his examples. In a way, this argument appears quite funny already in itself. It reminds one somewhat of the argument that Freud calls the 'borrowed kettle' argument. ('You blame me for having returned your kettle with holes in it? But, first, I did not borrow your kettle; second, it had holes in it already when I borrowed it; and third, I gave it back without holes in it'; cf. Freud [1900]: 138–9.) The two objections in this argument seem to contradict each other in just the same way: if Žižek was too quick the first time, then one should be glad of the chance of a repetition.

But what counts more is the fact that this kind of objection misrecognises the theoretical status of Žižek's examples. It takes the logical role of the example for its narrative role. It may be impolite to tell a joke a second time, given the fact that the action is about narrating jokes. Yet in Žižek's texts the jokes have a strictly logical function, and nobody would blame a philosopher like Hegel for repeatedly applying his notion of 'mediation' to diverse realities; or a mathematician for repeatedly using a formula that he or she has invented. This status of the theoretical tool is precisely that of the joke in Žižek's text. Thus we can understand Wittgenstein's idea of a philosophical book that consisted only of jokes, while being completely serious in itself (cf. Maruschi 1976: xiii). (Apart from Žižek's texts – and especially his recent joke-book [Žižek 2014] – *Capital* by Marx appears to come closest to this Wittgensteinian ideal.)[15]

We can sum this up by saying that the more materialist a philosopher is, the less he is disgusted by silly or dirty examples, and the less he gets bored by their repetition.[16] Yet there exists

another structural reason for the necessity of coming back to the same examples again and again. As Althusser has emphasised, it is not sufficient to break with an epistemological obstacle and to open up a new theoretical field. This cannot be done just once. Since the obstacle exists for reasons different from theory, it continues to exist and to accompany the new science, constantly menacing it, even from its inside. As Althusser puts it, 'not only does ideology precede every science, but ideology survives after the constitution of science, and despite its existence' (1990: 22). Therefore theory has got to keep its instruments in its hands. The 'epistemological cut' has to be made again and again. Its opponent is too sticky to let science go alone. Blaise Pascal observed this necessity of the repeated effort and gave a beautiful formula to it: 'These great mental efforts on which the soul occasionally lights are not things on which it dwells; it only jumps there for a moment, not for ever, as on the throne' (Pascal 1995: 251 §829). The repetition of Žižek's examples should enable us to jump back again from time to time to that 'throne' of thought that we may once have reached – thanks to these very examples.

Notes

1 Cf. http://www.dharma-haven.org/tibetan/digital-wheels.htm: 'His Holiness, the Dalai Lama, has said that having the mantra on your computer works the same as a traditional *Mani* wheel. As the digital image spins around on your hard drive, it sends the peaceful prayer of compassion to all directions and purifies the area.'

2 Žižek's analysis has been extremely productive. Apart from the discovery that beliefs and convictions can have an external existence, which has been crucial for a theory of ideology, it allowed another important conclusion with regard to art theory. At a moment when an ideology of interactivity appeared predominant in art, the example of canned laughter pointed in an

opposite direction: it was an artwork that contained its own observation. Here, the artwork did not leave some creative activity to the observers; on the contrary, it kept all for itself, even the 'passivity' of the observers. And apparently (as Žižek's own example seemed to prove) there were observers who wanted it to be like that: they did not want to observe, but preferred to delegate their observation to the artwork. Together with further examples (such as the use some TV freaks make of their video recorders), this led to a general theory of 'interpassivity': the wish for delegated consumption in art as well as in everyday culture (cf. Pfaller 1996; 1998; [ed.] 2000; Žižek 1998; 2004).

3 Cf. Nietzsche 1984: 269: 'alles Überwältigen und Herr-werden [ist] ein Neu-Interpretieren' ('everything . . . overpowering and dominating consist[s] of re-interpretation' [Nietzsche 2007: 51]).

4 Žižek, personal communication, Kulturwissenschaftliches Institut Essen, Germany, February 2001.

5 This is the way Octave Mannoni has conceived of a 'phenomenological' use of examples: 'd'essayer de présenter des exemples de façon, pour ainsi dire, qu'ils s'interprètent les uns par les autres' (Mannoni 1985a: 33).

6 Cf. Žižek 1997: 175–6: 'a well-known Soviet joke about Rabinovitch, a Jew who wants to emigrate. The bureaucrat at the emigration office asks him why; Rabinovitch answers: "There are two reasons why. The first is that I'm afraid that in the Soviet Union the Communists will lose power, there will be a counter-revolution and the new power will put all the blame for the Communist crimes on us, Jews – there will again be anti-Jewish pogroms . . ." "But," interrupts the bureaucrat, "this is pure nonsense, nothing can change in the Soviet Union, the power of the Communists will last forever!" "Well," responds Rabinovitch calmly, "that's my second reason." The logic is the same here as in the Hegelian proposition "the spirit is a bone": the very failure of the first reading gives us the true meaning.' Žižek provided an excellent new version of this joke in 1991, showing that after the disintegration of communism the same joke could be told again, simply by reversing the sequence of the two reasons (cf. Žižek 1991: 1).

7 Cf. Freud [1940a]: 174: 'for what we want to hear from our patient is not only what he knows and conceals from other people; he is to tell us too what he does *not* know'.

8 Cf. Kant: 'ein Beispiel [ist] nur das Besondere (concretum), als unter dem Allgemeinen nach Begriffen (abstractum) enthalten vorgestellt, und die bloß theoretische Darstellung eines Begriffs' (Kant 1978b: 620 [A 168], footnote; see also Kant 1965: B 171s.).

9 The counter-image lets us see that, previously, we were already dealing with an image. If an image 'holds us captive', this happens because its nature as image is not acknowledged, and mostly because the logic of this image in itself is not taken by its letter. This was emphasised by Nietzsche, in his criticism of the use of the optical metaphor in widespread notions of theory: 'But let us, forsooth, my philosophic colleagues, henceforth guard ourselves more carefully against the mythology of dangerous ideas, which has set up a "pure, will-less, painless, timeless subject of knowledge", let us protect ourselves from the tentacles of such contradictory ideas as "pure reason", "absolute spirituality", "knowledge in itself" – in these theories an eye that cannot be thought of is required to think, an eye which ex hypothesis has no direction at all, an eye in which the active and interpreting functions are cramped, are absent; those functions, I say, by means of which "abstract" seeing first became seeing something; in these theories consequently the absurd and nonsensical is always demanded of the eye. There is only a seeing from a perspective, only a "knowing" from a perspective' (Nietzsche 1910: 153). From this remark we can draw the conclusion *that there exists no philosophy which does not think in examples.* Yet some make believe that they do otherwise, since they do not present and treat their examples as such. They do not stick to their own letters but treat them as 'sleeping tropes'.

10 Cf. Nietzsche 1984: 281: 'Dergestalt dienten damals die Götter dazu, den Menschen bis zu einem gewissen Grade auch im Schlimmen zu rechtfertigen, sie dienten als Ursachen des Bösen – damals nahmen sie nicht die Strafe auf sich, sondern, wie es *vornehmer* ist, die Schuld . . .' ('In this way, the gods served to justify men to a certain degree, even if he was in the wrong they served as causes of evil – they did not, at that time, take the punishment on themselves, but rather, as is nobler, the guilt' [Nietzsche 2007: 56]).

11 Kasimir Malevich, in his theories of painting (cf. Malevich 1980), developed beautiful tableaus in which he analysed what he called the 'inspiring environment' of any given painters' movement: the inspiring environment of the Academic painter is a farm, with peasants and peaceful animals in front of it; the inspiring environment of the Impressionist is a feudal garden; that of the Futurist consists of ocean liners, locomotives and factories; and that of the Suprematist is skies filled with aeroplanes in geometrical formations. It would probably be revealing to do the same with philosophers. Very few would stand such a test as well as Žižek does.

12 Althusser 1993: 234: 'Ne pas juger de l'être par sa conscience de soi!'

13 For this, see Clemens, who remarks that Žižek's appetite 'finds its limit in poetry, more precisely lyric poetry' (Clemens 2005: 15).

14 For this, see, for example, Dean 2002. Dean's analysis is quite instructive, yet it does not account for the different functions that art takes on in Žižek's theory. Starting from Dean's thesis, it would have been good to analyse a few examples in Žižek's work in order not to commit the very mistake that Dean objects to in Žižek: to speak of his object with prefabricated ideas and without re-checking in detail. Apart from that, Dean succumbs to a major misunderstanding with regard to the Althusserian concept of 'symptomatic reading': this does not mean reading an artwork as a symptom of something else, but reading within an artwork (or a theoretical text) that which 'sticks out' – that is (in a theory), the answers without questions, or (in a story) those strange elements that do not have a function within the narrative (for example, the gingerbread house in the fairytale of Hänsel and Gretel). (For a more detailed account of the concept, see Pfaller 1992.) Žižek always uses the concept of symptomatic reading in the strict Althusserian sense (cf., for example, Žižek 1999: 10).

15 One could even imagine that, as Žižek once suggested, the examples in one of his texts were just the same as in another text, yet the complete theory was different.

16 This was clearly stated by Nietzsche in his remark about the necessity of 'rumination': 'Of course, in order to practise this style of reading as art, one thing is above all essential, something that today has been thoroughly forgotten – and so it will require still more time before my writings are "readable" – something for which one almost needs to be a cow, at any rate not a "modern man" – rumination.' ('Freilich tut, um dergestalt das Lesen als *Kunst* zu üben, eins vor allem not, was heutzutage gerade am besten verlernt worden ist – und darum hat es noch Zeit bis zur "Lesbarkeit" meiner Schriften –, zu dem man beinahe Kuh und jedenfalls nicht moderner Mensch sein muß: *das Wiederkäuen* . . .' (Nietzsche 1984: 216).

5

Against Participation

1 Participation: A Spontaneous Philosophy of Art that Blocks Art Production

Participation is on the agenda – perhaps even more than ever before. But its pervasive presence may possibly be the harbinger of its impending disappearance. Participation is being talked about not only in art, but also in everyday culture. It has even been introduced into the manifestos of political parties regarding how representative democracy should work. In all of these areas, there is hardly another term that better serves to describe current emancipatory claims. However, it is questionable whether a term such as this, which is used in such an inflationary and ambiguous way and is fraught with desires and hopes, is in a position to provide solutions – including solutions for the many various problems for which it is likewise called in: problems related to the lack of co-determination in public matters, problems related to access to an increasingly monopolised media public, problems related to how art deals with its public, etc.

What is worse, it may also be that on a theoretical level, like all hollow phrases, this term merely serves to feign solutions where problems first have to be precisely formulated in order to

91

become soluble, and that on a practical level it creates a trap, to the extent that it passes off precisely that which is in truth the problem itself as solution and liberation – namely, a form of the affirmative commissioning of individuals under the conditions of postmodern ideology.

If with regard to art I consequently assemble objections to the term 'participation', it is not to deny the entire genre of participatory art its right to exist. That would be unreasonable, since first, every genre of art succeeds in producing interesting works, even when the genre as a whole may appear to be questionable. And secondly, that sort of thing is in general not theory's responsibility: theory does not need to tell art *what it should do*. Art learns very well from its own experiences – its successes, its misfortunes and its necessary, from time to time very fruitful, failed experiments. But theory may tell art *what it does not need to think*. It can help art to rid itself of theoretical cumbersomeness and sentimental attachments, which as hip zeitgeist watchwords or words of hope may have had for a while an encouraging effect, but which as descriptions of that which art actually achieves and can achieve are more of an obstacle to artistic practice.

It occurs time after time not only in art but also in the sciences and in philosophy that – as Louis Althusser showed – self-reflection on these practices produces misleading 'spontaneous philosophies'. These supply a distorted image – for the most part formulated in a fashionable 'borrowed language' (borrowed, for example, from curators and other prompters) – of what has succeeded in the respective practice. However, this kind of self-image reacts upon the respective practice; it moulds it according to its own image and thus poses an enormous danger to its future success. I see the responsibility that theory has for art in

the marking and removal of such 'blockers', which obstruct an adequate self-image of artistic practice. The spontaneous philosophical programme of participation seems to me to be one of the greatest blockers for contemporary art. My argumentation is not directed against participatory art but against the philosophical programme with which it is coated – now and then beyond recognition.

2 The Philosophical Programme and its Key Preferences

Participation is a philosophical programme. Or more precisely: a specific philosophy speaks, like a ventriloquist, through the proclamations of participation. This philosophy also speaks, by the way, as it does through the participation that voluntarily or involuntarily lends it its voice, through the voice of other related and currently widespread political objectives – for example, through those of interactivity, of the openness of works of art or fields of action, of the performative turn or the intentionally modest 'low-hung' art (for these issues, see Eco 1989; Weibel 1999; Fischer-Lichte 2004; Ullrich 2003).

Because in philosophy errors never occur on their own, but rather, as Gaston Bachelard showed, always constitute a whole 'fabric', philosophy, which audibly murmurs through these political objectives, also has a structure of interrelated assumptions or preferences. It consists of a series of co-dependent terms, of which one is always privileged over the other. In the following, I would like to present these spontaneous and unreflected preferences using three examples, describe their consequences, and attempt to allow the respective opposites to become thinkable.

93

3 First Preference: 'Better to participate than spectate'

As did the Futurists, the Dadaists and the Surrealists before them, the artistic avant-garde of the 1960s regarded the dissolving of the separation between the performer and the viewer as a decisive goal of artistic progress: artists from the Fluxus, Happening and Vienna Actionism movements, members of the Vienna Group and many others worked on forms of audience involvement. This corresponded with the findings of Marshall McLuhan with regard to the world changing under the predominance of the new 'cool' media such as radio or television: 'Because television lacks detail, this results in high audience involvement' (McLuhan 1987: 483). Thus audience involvement in art seems to be a modern equivalent to that which occurred in the predominant media; McLuhan also explicitly took this into consideration for art (see McLuhan 2001: 122).

However, for McLuhan, being involved only meant that one was stimulated on all sensory levels and not – as is the case for the letterpress, a 'hot' medium – that one had to process detailed information on one single sensory channel after shutting down all the others. Due to its lack of detail, for McLuhan, television was a 'mosaic' that required completion by the viewer and for this reason produced his or her 'involvement' (McLuhan 1987: 474). Oddly enough, by the way, McLuhan does not appear to have taken into consideration the possibility of a totally 'un-involved', diverted and disinterested 'cool' way of looking at things, which is completely satisfied with the lack of detail and glares thoughtlessly at the tube.

In any case, McLuhan did not regard 'audience involvement' as what would soon be elevated to the central content of this concept: namely, the *dissolving of the division of labour between*

transmitters and receivers, that is, the permanent reversibility of the communication process. From now on, 'involvement' would be regarded as *participation*: not only through completing reception, but rather as a collaboration between transmitters and receivers in the materialisation of what is transmitted. In the 1960s, communication theory dreamed to a large extent of media through which everyone could transmit information to everyone else. In classroom situations in schools of all kinds, desks were no longer placed in rows but chairs were placed in a circle. And instead of didactic lectures and presentations, from now on there were to be discussions before or at least after each lesson.

With the onset of the civilian use of the Internet at the beginning of the 1990s, these at least thirty-year-old ideas found a massive technical equivalent in reality for the first time. This circumstance apparently made it more difficult to recognise the doubtful nature of these ideas. Paraphrasing a sentence from Adorno's *Negative Dialectics*, one might say: 'Philosophy, which seemed outdated, kept itself alive because in the end, the moment of its realization was not missed.'[1]

The heated art-market crisis at the end of the 1980s lent these ideas new impetus, even within the art world – at least in a newly emerged 'second sector', which now disengaged itself more and more from the highly remunerative private art market of the galleries and attempted to create a critical artistic counter-public in the art societies, in art spaces run by certain banks, and in other places not primarily devoted to art. Increased attention was paid to asserting criteria that opposed the private art market: anonymous groups instead of individual stars, temporary installations or situations instead of long-term exhibitions, scattering into peripheral spaces and curiosity for marginal groups instead of concentrating attention on a central

place, participation instead of the classic division into author-ship and reception.

Two philosophical premises silently played a decisive role in this triumphal march of participation: first, the idea *that the relation between transmitter and receiver represents a hierarchy and that the elimination of this hierarchy therefore has to amount to a democratisation*; and secondly, the idea *that it is more desirable for spectators to participate than to spectate: it gives them more pleasure and thus makes them happier, or it allows them less comfort and thus makes them freer.*

One can object to the first idea by saying that the relation between transmitter and receiver does not always represent a hierarchy. And when it does, then it is not always in favour of the transmitter: after all, there is *also* the petition, the cry for help, or the confession. Assuming a hierarchy resulted in a misleading theoretical fixation of interest on *transmitting*. The consequence of the conception of democratisation associated with it can be seen today in the talk shows: everyone can be on television provided that he or she is willing to present him- or herself as a freak and to reveal some allegedly weird intimacies ('I had sex with my ex', 'Necrophile: so what?', etc.). Now, because they have all been successfully committed to an interest in transmit-ting, one gives them satisfaction by allowing them just once to look into a camera. Not only with regard to sexuality, but in general with regard to the structure of the media public, what Michel Foucault remarked must therefore be recognised: we are no longer dealing with exclusion and repression, but rather with an extensive compulsion to produce and to confess. People are not prevented from doing something through bans or restricted access, rather they are constantly encouraged to produce them-selves in public.

However, this opportunity for everyone to be present makes it increasingly difficult to create a relevant public: a variety of private broadcasting stations now broadcast a variety of likewise private and trivial quirks. Instead of asking if one can find oneself on television, it would for this reason have been more important to ask whether something occurs on television that concerns one's own interests with respect to society and whether this is broadcast in such a way that it can be perceived within society. It is not *participation* with something *familiar*, but rather *sharing* in something *public* that would have been crucial. The philosophy of participation has successfully contributed to the confusion of these two very different claims.

4 Second Preference: 'Better active than passive!'

The fact that the audience's joining in on the political objectives of participation and interactivity is regarded as something un-questionably good and liberating is connected with another old philosophical error. In a certain philosophical tradition, activity is considered to be a condition of freedom; passivity, on the other hand, is the cause of non-freedom. Immanuel Kant, for example, had the following to say about this:

> Laziness and cowardice are the reasons why so great a portion of mankind, after nature has long since discharged them from external direction . . . nevertheless remains under lifelong tutelage, and why it is so easy for others to set themselves up as their guardians. It is so easy not to be of age. (Kant 1977a: 53)

What this means is that people are no more than lazy buggers who do nothing to take up the liberty to act, a liberty which is virtually handed to them on a plate. It is astonishing how little

infuriated dissent Kant reaped within German culture for this nimbly made transformation of political oppression into a plight for which the oppressed themselves are to blame.

It is not until it dawns on a philosopher that political conditions cannot be derived from the moral fault of individuals that a surprising conclusion becomes possible for him: namely, that people often not only *passively* accept their own oppression, but that they even *actively* fight for it as if it were their good fortune. Gilles Deleuze and Félix Guattari were right in stressing the meaning of this insight by the philosopher Spinoza in their *Anti-Oedipus* (Deleuze and Guattari 2000: 29). People are not only not free when they do nothing; rather, they are above all also not free when they mistakenly perceive their heteronymous actions as their own and believe that they are pursuing their very own interests, while without knowing it they are working for completely other interests.

This is why it is misleading to believe that activating the audience in art is automatically and always tantamount to their liberation. Because could not the exact opposite be the case: could the enthusiasm for joining in produced by art not deprive people of the necessary refractoriness that they would need in political life in order not to be immediately enthused by every neoliberal or reactionary or even fascist appeal to 'actively' join in, and pursue this with a feeling of liberation?

5 Third Preference: 'Better familiar than foreign!'

When people in art today often (but not always) let themselves be taught to do something familiar in preference to looking at something foreign, this corresponds to a general, extensive

change in Western societies. The American sociologist Richard Sennett keenly recognised this change as early as 1974 in his study *The Fall of Public Man*. Sennett maintained that in Western societies, a culture of public presentation – and consequently the separation between public and private appearance – was in the process of disappearing. As Sennett proves with a number of examples, since the Renaissance, Western societies had developed a pronounced culture of public presentation. It was a culture of 'as-if' that made a clear distinction between person and role. One dressed differently for the public realm to the way one did at home, and one moved and spoke in a different way. It was through this theatrical order of appearance that, for example, the squares in small Italian towns acquired a glamour and sophistication that fascinates visitors today.

However, it is precisely this playfully produced difference between the public and the private that – as Sennett observed – has been in the process of disappearing since the 1960s. Since then, relations in Western societies have been changing from an 'other-directed' condition to an 'inner-directed' one (Sennett 1978: 5). They lose (or eliminate) any dimension of public presentation and instead exclusively push ahead the person who is distinct from this public figure and who is regarded as authentic. As Sennett remarks, in this respect Western cultures are becoming increasingly self-centred and *narcissistic*: the 'probing question of what this person, this event "means for me"' becomes the decisive criterion for judging everything (Sennett 1978: 22). Everything that does not appear to completely agree with one's own self (or with the idealised image thereof) is perceived as unbearable 'alienation' or 'heteronomy'.

Art, too, is an area in which people were traditionally able to nurture a playful form of public appearance that was distinct from

99

their true self – probably the area *par excellence*, which served as a model for all other areas. As Sennett shows, since the Renaissance, forms of communication have developed in Europe that are *schooled by art*; people began to move like actors in public (see Sennett 1978: 107–22). Under the conditions of the narcissistic development of culture observed by Sennett, however, not even art has escaped the destruction of the public element.

Those developments in art that since the beginning of the 1990s – for the most part with an emancipatory intent and with corresponding reasoning – have aimed at eliminating any 'as-if' have to be seen from this point of view. This development does not solely affect a specific art of politics concerned with content, which neglects its formal possibilities because it does not view these as a political medium. The oppression of fictitious and playful elements also occurs in more playful connections. This is the case, for example, in the attempts to include the viewer described above: interactive high-tech installations and participatively structured low-budget fields of action in which everyone can join in are implemented equally to eliminate the separation between presentation and viewing. However, this often also means the loss of fictitious space. Everyone is now able to bring in *him- or herself*, but no one is able to show the others *what he or she is not*. It is hardly possible to separate the person from the role without separating the stage from the auditorium.

And because the viewers are denied their distance from the work, for their part they are no longer able to subject it to a critical reading: it is no longer possible to inquire into whether something quite different is being said from what the artist intended to say. 'One writes in order to become impersonal,' Giorgio Agamben remarked in an essay that deals with genius and that demonstrates the dissimilarity of this genius from the

person who often mistakenly believes him- or herself to possess it. 'Genius,' Agamben observes, on the other hand, 'is our life to the extent that it does not belong to us' (2005: 11).

It is precisely this foreignness, which for many years had its strongest social terrain in art, that is becoming increasingly suspicious under narcissistic cultural conditions that aim at 'self-realisation' and a 'creativity' that is interpreted as completely unproblematic. In the process, what is lost, however, is what perhaps makes up the most basic condition of *form* in art: the possibility of developing a voice that comes from somewhere other than from one's own standpoint; the chance of letting that text become audible that makes up the silent, secret imagination of the others, or that outrageous secret about society that none of its members can personally utter or uphold. If art ever had political influence, then it was at this formal level, because people and their own views are quite predictable; individuals becoming impersonal (and the articulation of opinions from an indefinite source), in contrast, often set the imaginary of everyone in motion, and thus rob the existing relations of power of their affective supports.

To make an appearance as something foreign also means, for example, that one can act in a sarcastic or cynical – or even excessively naive – way and play something evil. This kind of evil thing, which appears on the stage of art, can now and then create considerable difficulties for its counterparts in real life. Typically enough, however, in contemporary art something good is almost always played: the creativity of all of those present or the elimination of the 'hierarchy' between the performers and the viewers or co-determination in an intimate, harmonious community. It appears to be more than questionable, however, whether these optimistic, 'benign' games will ever be able to

101

possess critical value with respect to society; this problem is for the most part typically circumvented by viewing these games not as games but as the creation of little individual political realities – so to speak, as a miniature true life in a false one.

Although there is definitely a lot of playing going on in contemporary art, many of these games must for this reason be viewed as attempts at repulsion or at wiping out the element of play in culture. That 'as-if' that enables the making of a foreign appearance and that consciousness of 'not being authentic' that, as Johan Huizinga demonstrated, is the basis of all games is eliminated in favour of a narcissistic, that is, fiction-free space that has been cleansed of foreignness.

6 How Art's Critical Power becomes Obfuscated by its Spontaneous Philosophy

All philosophy, which ventriloquially acquires validity in the programmes of participation, interactivity and so on, has a narcissistic feature. The automatic and completely unrestricted 'Manichean' one-sidedness – that is, the spontaneous, irrevocable privileging of one side of each of the co-dependent terms mentioned – is proof of this narcissism: here, nothing is weighed out or soundly relativised through conditions; there is only ever something total here – and for everything total in emotional life, the imaginary, narcissistically charged self has supplied the model.

If, on the other hand, the question of the relation between production and reception in art succeeds in detaching itself from these kinds of Manichean co-dependent terms in the sense of 'good/evil', then it will also become possible to inquire into the *historical legitimacy* of a specific distribution. A more vigorous

inclusion of the audience does not necessarily have to be immediately celebrated as representing fundamental, enlightening human progress, whose abandonment would consequently be nothing more than a painful loss. Rather, it would be possible to explain and provide reasons for why a culture finds its way to such forms at a specific time, and why at another time it would perhaps do better to resort to other forms.

Only in this way will it succeed in recognising a critical value which interactive and participative practices in art might actually possess with respect to contemporary culture: might it not be conceivable that the inclusion of viewers in art could serve to allow them to become astute and alert, in particular with respect to attempts *of the same kind* to include them *in society*? The beginnings, for instance, of Action Art or Body Art (e.g., Günter Brus or Franko B), during which viewers were forced to ask themselves if they were able to calmly watch the self-violation being performed on the stage or if it would not be better to intervene, point strongly in this direction. The more recent, benign join-in actions in art spaces, which are marked by harmlessness and a strong need for harmony and which praise themselves for how 'creative' they allow all the participants to become, are much more suited to allowing this negatively mimetic function of art with respect to society to be completely forgotten.

Note

1 'Philosophie, die einmal überholt schien, erhält sich am Leben, weil der Augenblick ihrer Verwirklichung versäumt ward' (Adorno 1982: 15).

6

Matters of Generosity: On Art and Love

Obviously, art events are often occasions of generosity. You usually get a free glass of wine; you may get some free DJing or VJing; if you are lucky, even some free food. Yet the question here is whether art is not already in itself a practice of generosity. And if so, what happens to generosity if you make an art event out of art? In other words, what happens if you subject one practice of generosity (art) to another practice of generosity (the art event)? Does this bring about more generosity? Or maybe less? In the following, I want to investigate this question and look at it from a political perspective.

1 Lovers and Artists

In order to understand a crucial feature of art, it is useful to compare professional art practice with that of people who normally are not artists. Thus we can more easily discern a fundamental condition of artistic production. What is the necessary element that lets people who are not artists start making art? There is one fundamental condition: love – in its broadest meaning:

- in the erotic or sexual meaning, we can observe that non-artists become musicians when they are in love and want to sing songs for their beloved;
- in familial love, we can observe that little children make drawings to please their grandmothers or grandfathers for Christmas;
- among adult friends, it happens that someone writes for his friend's birthday a beautiful poem that funnily describes the virtues and vices of the birthday boy.

In all of these cases, where art production arises out of the desire to make a gift to the beloved, we will also observe three crucial features, which sociologist Marcel Mauss has described in his essay on the gift (Mauss 2002).

First, the gift must not be useful. What you present as a gift must be such that it cannot without difficulty be inserted into profane, everyday life. While it may be true, for example, that I can give my friend a shirt as a birthday present, the shirt still has at least to be a special one. Not a shirt that he can wear every day without remark, but rather a fancy party shirt with some glamour to it. What I can never do is to give my friend something that he might really need. If my friend is very poor, I cannot say, 'Hey Peter, listen, you are so poor – what if I pay your rent for December, as a Christmas gift?' On the level of gift making, we encounter here something that we may call 'abstraction' – that is, remoteness from utility, the first crucial feature that gift making has in common with art.

Second, the gift always has to be given. If, for example, I am invited to a wedding party and buy a fine bottle of wine as a present, but unfortunately fall ill on the day, then that bottle may commence an unpleasant, embarrassing, uncanny existence in

my apartment. I cannot hand it over to the married couple any more, but I cannot just drink it either. The bottle has become an obscene, obstinate object that refuses appropriation and integration into either their or my ordinary life. The same has been remarked, with regard to art, by the theorist of religion Klaus Heinrich who writes:

> Just as the art collector is not interested in his collection and has to transfer it – either, as a Maecenas, to the public, or, subterraneously to the underground safes – just in the same way the buyer of furniture aims at its fastest possible annihilation. The notion of the 'throwaway society' brings to mind the desire structure of the addict, the secret wish for annihilation. (Heinrich 1997: 55; my translation)

If the art collector who apparently loves art still has a desire to get rid of his collection, either by handing it over to the city or to the bunkers where nobody will see it for centuries, then this proves clearly that art is just as unbearable and problematic as the gift bottle that has not been handed over. (Mauss has noted this malignant, 'poison-like' side of the gift which is revealed by its use in the German language, where the word 'gift' means 'poison'.) Art, like the gift, proves to be difficult to possess. There is something to it that appears to resist all attempts at appropriation.

Third, the necessity to give occurs precisely when one has received. Giving means passing on what one has been given. As soon as one is undeservedly given something, one has to make an undeserved gift to someone else. I have learned this in small personal experiences. I often meet some friends for lunch. One day, one of the friends invited all of us, at his expense. This was quite unusual in this context, so we asked why. The friend

106

explained to us that he had just won a small amount of money on a bet, so he felt obliged to spend it together with us. The same seems to occur in art. Recently, a painter told me that she felt it to be nothing of her own merit but an undeserved gift to be able to see landscapes sometimes in a special way, and that she then felt obliged to paint this vision in order to pass the gift on to somebody else. The ability to see and the ability to paint are often perceived by artists as gifts, and their production is then meant as an attempt to make another gift in turn, as a response.

Traditional art has expressed this feeling of having received a gift in mythological narratives. The myth of the *genius*, for example, expresses this: the genius is not the artist himself but some other force that occasionally comes upon him and takes possession of him, like a demon. Giorgio Agamben has described this dimension of alterity inherent to artistic production: when dealing with the genius, artists, Agamben states, 'lend their lips to a voice that does not belong to them' (Agamben 2007: 14). Being gifted by the genius means dealing with something that cannot be appropriated, but is required to be passed on. Another myth by which traditional art has tried to account for this alterity is the myth of the *kiss of the muse*. Again, we encounter here the close relationship between art and love, when it comes to accounting for the initial moment of artistic productivity.

Of course, there is a methodological problem of how to deal with mythologies in a rational way. Should we enlightened people really lend our ears and brains to this apparently pre-modern crap? Or should we just dismiss it, as contemporary art often does when it says, 'There is no such thing as a genius. So beware of making ingenious art.' But is it a rational method to prohibit something that we have just beforehand declared

impossible? The answer from psychoanalysis to this problem of methodology is quite clear. Sigmund Freud would say that the myth has always got a reason for its existence. It therefore aptly indicates a reality, although it is not able to provide an explanation for it. Dealing in a rational way with a seemingly irrational mythology therefore involves finding out what reality the myth points to, and replacing the mythological 'explanation' with a theoretical one.

For example, the artists' feeling of owing their artistic ability to somebody else can clearly be explained in psychoanalytic terms. The psychoanalytic concept that accounts for this reality is *transference*. Transference is a certain way of relating to the other. In a relationship of transference, the external other assumes a position that is normally that of an internal psychic instance, for example, that of the ego-ideal. Thus, a psychic instance of one person becomes, so to speak, 'outsourced' to another person. Then two people visibly 'act out' something that normally would have occurred within the psyche of one person, as an invisible internal psychic drama.

Getting rid of this internal conflict and having one of its partisans outside opens up quite a few new possibilities for the psyche. Instead of distributing its energies and sharing them, for example, between producing something and criticising this very production, the psyche can now focus on just one thing, for example, production. Production alone, without internal criticism, can then become unrestricted, big, manic.

As we know, love is one mode of transference. This allows us to understand why many people are only able to produce art when they are in love. Only in this psychic state can they release their unrestricted, manic productivity. Without neglecting the differences between the professional artist and the loving

dilettante, I would claim that a certain type of love relationship is also necessary for the professional – maybe not just an incidental love with a single person, as in the case of the amateur, but a love relationship in general with an idealised public.

The specific 'manic' ability for art making only occurs when the artists manage to relate in such a way to this other, by loving this other. This ability is then transferred to them by others. And the artists feel this transference as soon as they feel that others expect something from them. When they want to satisfy this expectation, they are in love.

The uncanny feature that arises from this is, first, that the artists do not speak with their own voices. And, secondly, the product of this relationship, as a product of transference, turns out to be unbearable. It can only be made bearable when it is passed on, when it is transferred to somebody else. The transfer of the product appears then to respond to the transference that had stimulated its production. Giving away is a solution to the predicament of giftedness.

These uncanny features, I think, have to be kept in mind when we speak about events in contemporary art practice. Now, there is one fact about which we should not deceive ourselves; there is one crucial reason why we are facing such a proliferation of events in contemporary art. The reason is, simply, the fact that events produce numbers – numbers of observers, of visitors, of present people. And the fact that numbers are so important is because what we have to deal with here is – not the big winner, but – a side winner of the neoliberal privation of societies: *bureaucracy*. Bureaucracy is a side winner of the neoliberal economy. In all neoliberal societies, bureaucracy has increased – precisely through austerity measures. What bureaucracy does is to impose its own language upon all the fields that

it attempts to dominate. So instead of having experts observing and deciding about their fields of expertise by applying qualitative criteria, we have bureaucrats. The bureaucrats try to transform that language and impose instead a language that is understandable to them. As soon as bureaucrats dominate the process, numbers dominate quality.

For example, bureaucracy defines the value of university education only in terms of the number of students present at lectures and the number of academic qualifications. Yet the fact that these currently proliferating qualifications do not render these students suitable for employment is no longer the responsibility of bureaucracy. All these new graduates remain unemployed because they did not learn anything meaningful; they only had to be present at the university. But this is not what bureaucracy feels responsible for.

As soon as bureaucracy dominates a field, what happens is a reversal between a description and what is being described. The question is no longer: 'What is the real use, the proper functioning of this practice, and how can we appropriately account for it?' What now comes first is the account, the description, whose criteria are never questioned, and then the practice has to be modified so that it allows for a nice description. Bureaucracy always asks itself: 'What is the description that guarantees our own existence and survival as bureaucracy?' And it is precisely this description that it imposes on the things that it claims to make better. If, for example, numbers are the best criteria for the survival of bureaucracy, then bureaucracy imposes numbers upon university or museum life. Everything then has to be counted in numbers. If bureaucracy one day says these are good numbers, then politicians (at least, weak politicians) can believe that the process was a success.

This is the reason why we nowadays have to deal with a certain bureaucratically imposed generosity. Since art spaces have to prove that they have high numbers of visitors, they organise more and more events. These events bring visitors, and the fact that these visitors may not have looked at a single artwork, but have merely drunk a glass of wine or danced a little bit, does not affect the beautiful numbers. So what does this mean for the art field?

As I mentioned before, transference is a way of producing something that cannot be appropriated, and a way to deal with it. That which cannot be appropriated has again got a psychoanalytic name – *narcissism*. What we cannot appropriate is the most 'own' thing we know, ownness in itself, so to speak. A typical case of such ownness or narcissism is naivety; for example, in our culture, belief in Santa Claus. Of course, such narcissism would be unbearable to us; we only desire it as a happy state of mind retrospectively, once we have left it. Yet in family rituals, we bring this narcissism to life again by transferring it. The naive belief is ascribed to others – parents ascribe it to their children, but children also ascribe such naive belief to their parents: in order to get their parents' love, they act as if they still believe in Santa Claus.

One can observe this structure of mutual transference of naive belief quite clearly at the point when children reach about 12 years old. Up until then, one hears the parents secretly complaining to their friends about how much work Christmas is for them, but that, of course, it has to be done for the children. Only a very short time later, the children start complaining that they have to be at home for Christmas instead of being able to go out with their friends, but, of course, this has to be done for the parents.

111

2 Interpassivity: The Pleasure of Delegated Enjoyment

So what we find here is a mutual transference of narcissism, one more openly, the other more secretly. The enjoyment of this naive, narcissistic belief in Santa Claus thus always gets transferred to the other. For this type of enjoyment through the other, such indirect, vicarious enjoyment, I coined, many years ago, the notion of *interpassivity*. In interpassivity, enjoyment is delegated to some other. We transfer the narcissism to the other in order to make the other enjoy in our place. This is the basic formula of interpassivity: *I want the other to enjoy in my place.* For myself, enjoyment is unbearable, so I look desperately for some other idiot who can enjoy in my place, and I am happy if I find one.

Interpassive behaviour thus always involves a certain 'as if': parents act as if Santa Claus existed, children act as if they believed in Santa Claus. So the illusion contained in the 'as if' might very well be nobody's illusion. Nobody needs to be the real believer here. The 'as if' alone allows for the transference, for the circulation of the unbearable illusion. It keeps this illusion at a safe distance, by putting some more or less fictitious naive other between oneself and the illusion. (Or, in other words: it puts the narcissistic other between everybody and narcissism.)

Of course, the same 'as if' also occurs in the art event (as Beti Žerovc has pointed out nicely [2012: 19–20]). In the art event, this also has to do with a crucial 'as if', since we replace the real confrontation of the observer with the artwork by a small, symbolic contact. We can call this symbolic encounter a case of interpassivity: somebody else could have believed that this had been a real observation of the artwork since the visitors were present and near to it. The visitors themselves do not have

to believe this; yet they may quite appropriately say, 'I have seen the Nauman video at the exhibition – I mean, I heard it vaguely from the other room when I was drinking a glass of wine with my friend at the art event.' This is quite appropriate, and I would claim that this is the basic form of civilised behaviour and culture: the fundamentally unbearable character of the artwork (the causes of which have been explained before) is thus rendered bearable. By acting 'as if', the observers keep the unbearable features of the artwork at a safe distance. What they cannot appropriate themselves, they pass on to an illusion of appropriation (an illusion that some naive other may believe in). Without getting into too close touch with the artwork, they can thus profit from the 'as if', from the illusion of contact that they have established.

All the well-known claims that observers should really see the artwork are therefore in a way barbaric and misleading, because they overlook a crucial fact concerning profiting from something. All these claims that observers should get into direct contact with the artwork and that they should interact with it simply neglect the fact that profiting from something – at least in capitalism – does not stem from collaboration or from participating. The people who profit from something within the capitalist economy are not those who participate or collaborate actively in it; rather, they are those who are passive and figure as remote shareholders, while some other idiots collaborate in some other room. This principle should also be applied to culture. Those people who really profit in culture are not those who collaborate actively and get into direct contact with the artworks. Rather, they are those who establish and maintain a certain civilised 'as if'. Interpassive observers are thus the shareholding profiteers of the artworks.

Up to this point, the art event appears as a quite civilised and very contemporary practice, matching the key principles of capitalism. When the efficiency of the museum is more and more measured by numbers of visitors, the art event is the perfect answer to this neoliberal standard. It allows for the increasing of the number of visitors without changing anything in the 'economy of attention' (as Georg Franck has called it [Franck 1998]) – that is, the time of observation available on the side of the observers, and the time required by the artworks.

3 Interpassivity of the Event and Interpassivity of the Art Museum

So what might be wrong with the art event? I would claim that the problem lies precisely in the fact that the interpassivity of the event obscures, or even destroys, the interpassivity that the art space already has in and of itself – since the museum, the gallery, just like the theatre, the opera house and so on, already work for society as interpassive media: they produce observation in the place of absent observers. You do not have to attend the event in order to hear the noise from the Bruce Nauman video from the other room. Rather, it is sufficient to know that there is a gallery in the city where it is being shown. There is a fundamental interpassivity to the art institution: if something takes place there, it is as if somebody has seen it. Thus, these institutions give relief to everybody, doing all the art things vicariously. Here, the cultural shareholding has already started.

So the crucial problem with the art event is the fact that it brings about a reduction – a reduction in terms of the scope of this shareholding. Instead of letting virtually everybody hold a share in culture, the event only lets a limited number of people

hold a share in it. Only the people who are physically present can become shareholders of what they have not seen, whereas the museum as a structure allows for shareholding by virtually everybody. Profit only for the people who are physically present would, in sociological terms, be the model of *community*. Community is the place where only those who are physically present can profit – a limited number of people who almost all know each other, as in the art scene. An unlimited number of shareholders, on the contrary, would constitute the socio-logical formula of *society*. So I would claim that the reactionary dimension of the art event lies in the fact that it reduces society to community. The event is the attribution of shareholding and artistic citizenship only to the people present, and a denial of these qualities to all others. It is the exclusion of the majority from interpassive artistic citizenship; a denial of the universal human right of profiting from art through passive shareholding.

This also involves a reduction in terms of time: the *event* thus represents for art what the *project* (another neoliberal invention) is for science – both replace a permanent, universal structure that serves society with a temporal, exclusive happening that only serves a certain community (of course, with all of the neo-liberal consequences, of precarious, limited contracts, uncertain payment, etc.).

Here we can see the political consequences of our brief con-sideration: insisting on love and transference, and interpassivity, as necessary conditions of art and culture means

- breaking with the imposition of bureaucracy and its standards; and
- giving the human right of cultural shareholding back to the entire society.

115

4 Summary

Artworks share some crucial features with gifts – even when they are not given as gifts. For instance, they are not useful, and they are difficult to possess. Above all, they are created under conditions of transference: they respond to a presumed desire of the other. This other is then put into the position of the artist's ego-ideal. This replacement is what Freud called love. Yet for love, it is not always advantageous to feel the other's physical presence. The same seems to go for art, too: the more we make the other present, the less we can establish transference and use it to produce its specific artistic effects. The proliferation of the art event thus contributes to the disenchantment of art.

7

What Reveals the Taste of the City: The Ethics of Urbanity

1 Urbanity as a Virtue

Urbanity, as understood by the ancients, is not a characteristic of large or densely populated settlements, but a human ability – a virtue. Thus, in his rhetoric Cicero refers to an urbane, sophisticated manner, which includes the ability to make witty puns and double entendres, as *urbanitas*.[1] Such cultural achievement could, according to Cicero, only have been established in urban areas. Some 150 years after Cicero, the rhetorician Quintilian restricted the meaning of the term to an element of speech – not without emphasising once again that this witty style of speaking 'exhibits in the choice of words, in tone, and in manner, a certain taste of the city'.[2] In the Renaissance, Baldassare Castiglione recalled the ideal of urbanity in his treatise on the courtier – though, because of the courtly context, rarely under that name. Thereby he referred to the ability to engage in amusing and pleasant conversations.[3] In the seventeenth century, Emanuele Tesauro followed the ideas of Quintilian and used the term *urbanità* again to denote a writer's ability to create witty conceits (*argutezze*) through the use of tropes and figures such as metaphors.[4] All the above-mentioned writers agree on the fact that witticism as well

as poetic and creative genius (which can, according to Tesauro, also be manifest in works of visual art) are forms of humour that have as their prerequisite the atmosphere of the city. Perhaps it is useful to recall the definition of urbanity as *habitus*, as an ethical attitude influenced by the atmosphere of the city and the aesthetic ability that results from it. In the following, I will try to show precisely what the city, from antiquity onwards, can induce in people; what distinction it has from the non-urban; and what ethics – what principles, modes of behaviour and forms of organisation of the social imaginary – are a necessary and indispensable part of urbanity. This can contribute to an understanding of why urbanity is not a quality that, as we know all too well, belongs to cities automatically; why, as Friedrich Achleitner once observed, even a small ancient city like Cividale is more urban than a large modern city like Stuttgart; and what needs to be done in order that, in the future, our cities have more of what reveals the taste of the city.

2 'We are an urban café, and you are making a mess here'

When *urbanitas* is thus understood by rhetoricians and poetologists as the ability to intersperse spoken texts (as well as content in other media) with amusing, inspiring, ludic elements, and to induce in the audience feelings of excitement and laughter, it is contrasted with the plain austerity of goal-oriented communication, but not only that. This urban affair is not only about revealing, in addition to objective prudence (*prudenza*), a ludic element of ingenuity (*ingegno*) or genius.[5] Speech should also be elegant, 'clear, agreeable, and polished, that is, of such a kind that nothing of the rustic or the foreign be heard in it'.[6] Thus,

a ludic, amusing, urban mode of speaking is contrasted with a rustic, rural one as its opposite.[7]

However, this contrast raises, against all apparent evidence, some questions. Can rural speech never be cheerful or ludic? Isn't there such a thing as peasant laughter?[8] Isn't rural life – especially as imagined by educated writers – characterised by a certain frivolous exuberance, by a penchant for pranks and jokes (no matter how coarse they are)? In fact, when theoreticians like Tesauro look for witty conceits, *argutezze*, in speech, rural, or at least suburban, vernacular speaking should especially be taken into consideration. When speakers – even particularly educated and refined ones – are driven by an emotional charge rather than by prudence, they tend to switch to the vernacular, which may produce exhilarating effects: 'The proud edifice of my hopes has burned down uninsured; my fortune's stock has fallen by a hundred percent, and that brings my net worth to a good round sum, namely zero', as is stated by Johan Nestroy's hero Titus Feuerfuchs in the comedy *The Talisman* (Act 3, Scene 1).

The same effective oscillation between different levels of language and culture was identified by Roland Barthes in the work of the Marquis de Sade. It displays a form of 'metonymic violence', which overturns – in one single sentence – all sorts of things, 'the social fetishes, kings, ministers, ecclesiastics, etc., but so too the language, the traditional classes of writing' (Barthes 1989: 33–4). Thus, Sade's *120 Days of Sodom*, for example, includes passages such as the following:

'Président, your prick is in the air again,' said the Duc; 'your fucking remarks always betray you.' 'My prick in the air? No,' the Président said, 'but I am on the verge of getting some shit from our dear little Sophie, and I have high hopes her delicious turd will precipitate something. Oh, upon my soul, even more

than I'd suspected,' said Curval, after he'd gobbled up the hash;
'by the good God I'd like to fuck, I believe that my prick is
taking on some consistency.' (Sade 2008: 298)

Does the wording of Sade's work not resemble the stanzas
of Helmut Qualtinger's and Gerhard Bronner's song of the
'G'schupfte Ferdl', which says, for example, the following?

und mit Elastizität
die sich von selber versteht
schleift der Ferdinand die Mitzi aufs Parkett[9]

The aesthetic appeal of such a transition between levels of
language, it seems, is the reason why people, using language that
becomes more poetic due to its strong emotional loading – as
in cursing and swearing – abruptly switch to the vernacular.[10]
'Ta gueule', 'Hold your tongue' – can there ever be an equiva-
lent expression in the standard language? And isn't the French
language admired exactly for its richness in vivid, picturesque,
strong and vernacular elements, which are regularly interwoven
in elaborate speech? In a similar vein, Viennese German is at
the height of its poetic power, which is used with masterly skill
by dialect poets and singer-songwriters such as Georg Danzer,
when it switches immediately from a polite or stilted standard
to a melodious dialect or a vernacular loanword from French:
'er ziagt si seine Schuach aus und sagt nur "Bitte gusch"' ('he
takes off his shoes and just says, "Please, shut up"'), as is said on
one occasion in Danzer's song 'Hupf in Gatsch' (Jump into the
mud). Or as in Danzer's 'Jö schau' (Look at that): 'Der Ober
Fritz sagt "Wir sind hier ein Stadtcafé, und was Sie da mach'n,
is a Schweinerei"' ('The waiter Fritz says, "We are an urban café,
and you are making a mess here"'). Thus, a palatable, subcultural

form of *argot*, which almost works as a local secret language, is most likely to correspond to what has *argutezza*, to what is *argut*.

3 Urban Minds on a Country Trip

It may be suggested that what rhetoricians referred to as specific-ally 'urban' is not so much the result of its restriction to a purified urban terrain, wrested from a supposedly barbarian hinterland, but of a skilful movement between these two areas, which is only possible from a fully developed city. Or, as is stated by the philosopher Alain: 'What the city dweller especially likes about the country is the going there' (Alain 1973: 242). From this per-spective, urbanity is not defined as the knowledge of the rules of decent behaviour and taste, which may also be familiar to the rural population. Urbanity may rather be seen as the deliberate breaking of these rules and the transgression of 'good' taste. Only a city dweller could take pleasure in raw nature, for instance; to a country dweller, by contrast, this would seem absurd, as Kant notes in his treatise on the sublime: 'So the good, and indeed intelligent, Savoyard peasant (as Herr von Saussure relates) un-hesitatingly called all lovers of snow-mountains fools' (Kant 2007: 78 §29). All aesthetics of the uncultivated or of bad taste, such as the aesthetics of 'camp' described by Susan Sontag (cf. Sontag 2001b), are based on the principle of an 'urbanity' that prefers to operate outside expected civilised spaces and territories. Only there can it turn the hideous, threatening, terrifying, shocking, naive and kitschy, which may be unhesitatingly abhorred by people – like the Savoyard peasant – of some intelligence and taste, into something wonderful, noble, 'sublime'. One must have an abundance of taste to take pleasure in the most tasteless

things. And one must have a more complex taste to take great pleasure in the simplest things, as is remarked by Oscar Wilde's character, Lord Illingworth, on one occasion.[11] The production of witty conceits, appeals, frivolities and *argutezze*, which is a characteristic of urbanity, may thus be regarded as a process of 'sublimation', taking as its raw material things that are far below the standards of good taste and raising them to an unexpected level of cultural appreciation.[12] The pleasure one takes in this is not so much owed to the material itself; it is rather a pleasure that urbanity – as a perspective – takes in itself. Whenever – apart from all cultural constructions – one experiences the sublime, one can refer to Kant with complacency: 'and the mind must already be filled with manifold Ideas if it is to be determined by such an intuition to a feeling itself sublime [. . .]' (Kant 2007: 62 §23). The same complacent perspective, which takes its pleasure from deficient objects to reassure itself of its own richness of ideas, can be observed in the protagonists of the Marquis de Sade. One of them states on one occasion: 'The man who is addressing you at this very instant has owed spasms to stealing, murdering, committing arson, and he is perfectly sure that it is not the object of libertine intentions which fire us, but the idea of evil' (Sade 2008: 141).

Urbanity is not necessarily found only in the city, but also in the wilderness of nature, in – morally and aesthetically – deserted wastelands as well as in the lowlands of the deepest levels of culture and language: it is found in the 'mind' of the city dweller, who visits these places with curiosity. Hence, urbanity is not defined by the absence of rural or rustic elements, but as an urban relationship to rural – as well as to urban – elements. Thus, it cannot be ruled out that urbanity also exists in rural areas. A prerequisite, however, is – in the absence of densely

populated settlements and of opportunities for anonymous en-
counters – the existence of modes of behaviour corresponding
to an ethics of urbanity, which will be described in the following.

4 The Obligation to Play. Humour as an Act of Politeness

A pleasing trip, on the level of space or language, to the country-
side immediately suggests itself when the city is merely seen as a
space for work. The attitude of urbanity, however, is opposed to
an atmosphere of pure purposefulness and usefulness – even if it
is that of the city. Urbanity is characterised, as Tesauro remarks,
by 'a certain disgust for ordinary though useful things, when
usefulness is not combined with variety, and variety not with
pleasure' (Lange 1968: 37). *To adorn things with lightness and allure*
by using witty expressions is an act of urban refinement to which
Cicero felt obliged: 'A certain intellectual grace must also be
extracted from every kind of refinement [*ex omni genere urbanita-
tis facetiarum quidam lepos*], with which, as with salt, every oration
must be seasoned.'[13] Thus, to be urban is to season – maybe even
with rustic pepper at times. Only when urbanity is understood
not as the absence of such spicy, sometimes rural, elements but as
their urban use can the tension or apparent conflict between the
required lightness and the seasoning be resolved. Something is
urban only when the seasoning also becomes light – and when it
is used to rescue all other things from the boredom of purposive-
ness and lift them into lightness.

There is yet another dimension to Cicero's remark: namely
the demand for refined, urban speech. Urbanity thus should not
only be seen as the knowledge and the ability to play with words;
there is also an *ethical obligation* to engage in such play. In certain

circumstances *one must play* so as not to become a fool who bores people with mere factual information. Ready wit and brevity of response are, according to Cicero, of utmost importance.[14]

One must be brief, because only brevity carries lightness, wit and spice. The obligation to play is, as observed by the cultural theorist Johan Huizinga, a crucial cultural function of play: a game not only has rules by which it is played, but also an imperative power by which it dictates that it must be played – here and now (see Huizinga 1950: 10; cf. Pfaller 2014: 83–8). The obligation to play with words, to create ingenious conceits, to prevent boredom, and to be brief and witty reveals that cultures of humour and cultures of politeness appear to be of the same origin. To have a sense of humour is an act of politeness that developed in ancient cities and later again in Renaissance city-states. And politeness is itself a game – a 'comedy' according to Alain:[15] everyone is invited to stand back from oneself a little, not to take oneself too seriously, as one might tend to do, and to play a role instead that is pleasant to others.

Thus we can explain why – and under which conditions – even rustic elements of discourse can contribute to urbanity: they belong to civilised behaviour insofar as they allow the speakers not to take themselves too seriously; insofar as they function, for the urban people, to arrive at a humorous distance from themselves and to become 'impersonal'; in other words: insofar as they function as a mask.

5 The Urban 'As If'

The role one must play according to the dictates of urbanity is to keep up, against one's better judgement, a certain appearance.

One has to act as if one was concerned for the well-being of others; one has to act as if one was in cheerful spirits; or as if one had not noticed the presence of others – or, at least, certain pieces of evidence for their existence.

By this means, urbanity forges a new bond between individuals. This bond no longer rests on 'mechanical solidarity',[16] which is an attribute of social *communities* and is based on a shared characteristic: people belong to the same family or the same football club, listen to the same music, and so on. Urbanity replaces the bond between familiar individuals with a bond between unfamiliar ones. The latter provides the basis for an abstract, 'organic solidarity', by which *societies* are characterised. Organic solidarity does not rely on shared characteristics of group members, but on the premise that all members have the ability to leave these characteristics behind for some time – as long as they move in urban, public space. Such transcending of one's own defining characteristics, affiliations and peculiarities implies the ability to create a fiction, an 'as if'. What is remarkable about this fiction is that none of the people concerned has to function as a carrier of the illusion. No one has to believe in the illusion, and no one has to be regarded as its naive carrier, while its substance can indeed form a material reality in that particular society. For instance, politeness, where it exists, is a material fact that has various significant effects on the coexistence of individuals, even though it is, as Kant lucidly stated, a deception with no one deceived.[17] The psychoanalyst Octave Mannoni has observed that the same is true for various artistic and cultural processes, such as the theatre, where the spectators are actually not deceived by the actors, but, fully aware of the illusion, 'conspire with them', to use Mannoni's words, and act as their accomplices (Mannoni 1985a: 19). Instead of the

idea that someone is actually deceived, the theory must assume an invisible, psychic instance of observation – a virtual 'naive observer' only concerned with external appearances – to give an account of the reality of the processes that are determined by fiction.[18] This is precisely the kind of observer we discovered in interpassivity theory, when we came upon the 'illusions without a subject' and the interpassivity pertaining to rituals (see above, Chapter 3). Since urbanity is based on beliefs without believers, the urban bond of organic solidarity is formed by interpassivity. This becomes particularly clear when one looks at how urbanity deals with narcissism and intimacy.

6 Cosmopolitan Masquerades

Urbanity in the sense of civility is, according to Richard Sennett, a matter of 'burdening others [not] with oneself' (Sennett 1978: 336). The precious narcissistic ego is abandoned for a more civilised role. Instead of familiar individuals, now flexible masks encounter each other in the city; fictional characters that do not reveal much intimate information and thus are less vulnerable. As a result, the city is turned into a prime space of discretion. This was observed by René Descartes in a letter of 5 May 1631 with regard to Amsterdam, in which he declares euphorically that, thanks to this city, he has finally found a place where he can walk undisturbed and alone as if he were in the woods: 'I take a walk each day amid the bustle of the crowd with as much freedom and repose as you could obtain in your leafy groves, and I pay no more attention to the people I meet than I would to the trees in your woods or the animals that browse there' (Descartes 1949: 57–8 Letter 8). Here again, urbanity is not seen as opposed

to nature but only to the warmth, security and familiarity of rural settlements, characteristics that then could – in Descartes' view – be attributed even to Paris.

7 Sex, Fiction and the City

It is due to its discreet atmosphere that in the city, among other things, other forms of love are possible than in the countryside, where early marriage is so prevalent and everyone knows everything about everyone else. This is not necessarily the case in the city. The TV series *Sex and the City* deals with this aspect, set in that historical moment at the end of the twentieth century when it was possible for women for the first time to act like men in this respect. One chooses to remain unmarried for longer periods because the acquisition of urban education takes a lot of time, and afterwards, having a well-paid job, one is not required to establish a joint household immediately. The narcissism of the romantic desire for the one perfect partner and a complete union with him or her can actually be treated in a civilised manner – as a fiction. Of course, as with Santa Claus, one may act as if the perfect person for love does really exist (and, against better judgement, take great pleasure in unwrapping one's presents). While the extent of disenchantment may be much greater in rural or suburban areas, which can lead to real hells of togetherness, in the city desire can be kept alive much longer. Of course, one should have left behind any rural naivety and should not claim from reality what is offered by fiction. Masks can be faithful, even if people – due to the rich range of urban possibilities and opportunities – are not. People may be aware of that – but the masks themselves do not have to be aware of people's awareness.

It is something completely different to have – fortunately or un-fortunately – a secret revealed than to destroy the corresponding fiction in that act of revealing. Urbanity is, in fact, the ability to differentiate between the awareness of those actually present and the awareness of the instance of observation – this means having respect for a fiction even if it is not one's own, and keeping up appearances. In a few lucky cases it may be that people are just as they are represented by their masks – like Schiller's character of the 'beautiful soul', whose inclination is driven by its inner nature to what is required by duty (Schiller 2005: 203–4).

But maybe this can be managed more successfully when the true face is given the chance to pass – wrongly – as a mere mask. It is probably easier to have no secrets at all when this is exactly what may remain a secret. Realities, not only in the city, are fragile creatures that are better created under the veil of a fiction. Prime examples of this are those movie scenes where people who have just become closer and arrived at the front door face the question of whether or not to spend the night together, and decide to put on an act; for instance, one person might say: 'Would you like to come in for a coffee?' Even though all parties concerned are able, as is usual among civilised people, to see through the fiction and notice the little white lie, they need to feign ignorance to make the plan work. What is at work here is, again, the urban demand for lightness. One has to put on an act. The romantic comedy *Sex and the City* uses many examples to teach us that putting on an act is an essential part of life – without which there can be none that is worthy of the name.

8 When the Masks Come Off: The Crisis of Fiction

Today, over a decade after *Sex and the City*, one particular sentence is often heard in certain TV series, which – with good reason – was never uttered in *Sex and the City*. One can hear spouses actually say: 'We don't have secrets from each other.' This is a profoundly urban sentence, for in the village it would appear self-evident and thus would make no sense. It is only in the city that such a severe form of anti-urbanism can emerge. In the city – that is, where the need to play once seemed to be so forceful and tempting – in some situations a complete refusal to play games, a spoiling of the game, can occur. Certainly, such a sentence can be an especially refined part of the game, but this is not the case in the dark postmodern world we are living in. Evidently, people have lost their penchant for games and masks. Richard Sennett comments on this:

> I have sometimes thought about this [. . .] in terms of the masks of self which manners and the rituals of politeness create. These masks have ceased to matter in impersonal situations or seem to be the property only of snobs; [. . .] I wonder if this contempt for ritual masks of sociability has not really made us more primitive culturally than the simplest tribe of hunters and gatherers. (Sennett 1978: 15)

A recent example of this trend is the sudden boom in plastic surgery. Not long ago, beauty was perceived as a tongue-in-cheek game, a fiction, a deception without deceiving anyone; it was seen as a role that must be fulfilled – by wearing costumes and make-up – only to a certain extent. Today, however, most people believe that beauty is a truth (or something believable, which implies actually deceiving someone), and they can only

be beautiful when their 'real' body is beautiful. This is why they go under the knife. One could compare this to actors who believe they can only perform a fight scene realistically and convincingly when they slash at each other with real knives onstage.

Admittedly, postmodern individuals, devoid of all utopias and grand narratives, no longer have any great idea of beauty. They think that to be beautiful means to bother no one with their body. Everything that may be bothering is thus eliminated. They are no longer familiar with the idea that the irregular, the deviant is something to take great pleasure and delight in – just as they are no longer familiar with coarse words in urban speech. Cleopatra's nose, used by Blaise Pascal as a prime example of 'that certain something' or 'je ne sais quoi',[19] today would call for plastic surgery. A society that considers itself a knowledge society does not know anything about 'je ne sais quoi'.

9 That Certain Something, the Fetish and the City

Generally, 'that certain something' is an entity that eludes all knowledge and labelling. The speechlessness and ignorance of those who are enchanted may only be pretended at times and may actually refer to a property or quality of the appealing object that can be grasped by knowledge and can be labelled (be it a beloved person or a work of art). But, as Ludwig Wittgenstein said, there can be counterfeit money, but not all money could be counterfeit. There is always something that can only be labelled with negative words. Ontologically, it seems, 'that certain something' is not on the same level as all the other objects that can be labelled. In this system of objects, it represents something like a disruption; it cannot always be seen or perceived in the same

way as the other objects, and it cannot be perceived – if at all – by all observers in the same way. There are many who consider it to be meaningless or ugly, like a nose that is a bit too long. Only those whose minds are 'already [. . .] filled with manifold Ideas', to use the words of Kant, can perceive this no-thing, this non-object, as a grand, sublime object – as if it were the embodiment of *acutezza*. If they are only able to describe this kind of disruptive object in vague terms, which are only understood by those whose minds are also filled with ideas, this is because something different from merely its redundant qualities shines from it to them. It is due to its status as a disruption within the system of empirical objects that the object can reflect to them its own richness of ideas. Especially from the perspective of urbanity, the ontological status of 'that certain something' can be conceived: it is something that, as an enlightened urban person should know, is not available in the real world, but which is in lucky cases *alluded* to by certain irregularities of the objects; or, at least, these irregularities can be read as such allusions. 'That certain something' is the blind spot of an object that is capable of an 'anamorphic' transformation and that can, from an urban perspective, itself light up in the form of an urban witty conceit. The 'glance at the nose' of certain women, which fascinated a fetishistic patient of Sigmund Freud (Freud [1927a]: 383–4), is a – more complex – example of this; a phenomenon shaped by an urban wordplay that can only be perceived from a particular subjective perspective. The fetish is a profoundly urban phenomenon (for this, see Krips 1999).

10 Losing Lightness: The Appropriation of Belief

A society that does not tolerate fictions – or a deception without deceiving anyone – has lost any sense of beauty, of 'that certain something' and of the fetish. This intolerance towards urban, civilised fictions is a characteristic of postmodernity. For it is, unlike what it believes, in no way an enlightened, sceptical era. It is not the case that it does not want any illusions; it only wants those illusions that one can fully believe. It always demands complete identification with the illusions; it is obsessed with the ability to believe oneself (see Pfaller 2008: 92–5; 2014: 10–14). The result of this is willingly referred to as 'identity'. In order that everyone can be oneself and believe in this, everyone must constantly tamper with one's identity so that one does not have to assume anything that is believed by others, that is light, or a role in society. It is revealing that, once one has started the construction of the self, it is not likely ever to be finished: the stronger the need to believe oneself, the rarer the objects qualified for that; anything suspected of merely serving the illusions of a virtual, invisible observer is deemed ineligible and eliminated without mercy. Hence, no longer can one encounter the other with lightness but only with 'gravity', no longer under the guise of one's role but as – (supposedly) true – identity. As a result, one constantly burdens the other with one's self, or with what one thinks it is. So it is really no wonder that everyone gets on each other's nerves. The other is no longer seen as someone who puts on an act for the sake of others, to be pleasant to others, but as someone who willingly lives up to his identity – at the expense of others. The others, who can hardly find anything to truly believe in, regard everything the other represents as his undisrupted, natural essence. Thus postmodern (self-)constructivism

132

leads to an essentialisation and – secretly envious – contempt of the other; and consequently to a 'culture of complaint', about him and his supposedly unbowed pleasure.[20]

11 The Baby Boom of Anti-urban Forces: Retribalisation and New Infantilism

At the present time, there are at least two forms of this general pattern at work: retribalisation and infantilism. Since the 1960s, Marshall McLuhan argued, Western cultures have been 'cooling down' considerably.[21] Instead of the letterpress, a medium rich in detail that enhances one single sense, now there are many dominant media, which – like television – involve all the senses at the same time but are poor in detail. When letterpress printing was the dominant medium, according to McLuhan, the world 'exploded', whereas in the twentieth century it is 'imploding' into a new tribal culture, which is again based on mechanical solidarity – so that people are only concerned about 'communities' but not about society. The world is no longer made up of elegant metropolises but is a 'global village', where everyone knows each other's face, but no one is able to remember or even criticise what someone said. One consequence of this is, as Sennett notes, that politicians are only judged by their looks or their private lives rather than by their agendas or their actions. The retribalisation through the media of the twentieth and twenty-first centuries results in the 'tyranny of intimacy' that was predicted by Sennett as a danger.

Concomitant with the implosion of the world is the infantilism of its population. Particularly influenced by television and rock music, the notion of 'youth' has been booming since the

1960s. Even though these youths appeared to be rebellious and heroic on their first appearance, ready to throw over the rules of the adult establishment, it is also typical of them that today, under more severe economic and political circumstances, they are willing to let others tell them what to do, for example at university, and even accept, if not welcome, the bans and prohibitions that rob them of their small liberties, such as smoking. The legitimate offspring of 'professional youths' are 'professional kids'. At least they dress as if they were kids, wear shorts and trainers, and are afraid of any sort of alleged danger; on the other hand, they are precocious enough to hail any alleged act of common sense. This new infantilism of contemporary adults – or life-long adolescents – is also responsible for eliminating the games of urbanity.

Being polite, sophisticated, charming and witty requires an ability that is, as Sigmund Freud argued, completely unchild-like: humour. Humour is the ability to look down benignly on oneself (and on others as well) and to tolerate benevolently little follies and puerilities as civilised fictions.[22] This ability is absent in precocious neo-children, who – like all children – want to be adults at all costs and always to be taken seriously, which is why they are, as their supposed better judgement dictates, vehemently opposed to any form of civilised fiction, and thus reveal their hopeless childishness.

12 Urban Savages

One might argue that this loss of urbanity is a necessary side effect of an unstoppable cooling down of culture. From this perspective, the assertion that there was a time when everything was

different and thus might be different again cannot be anything other than hopelessly backward-looking nostalgia. In return for losing the ability to treat each other in a civilised manner and constantly feeling bothered by each other, so the argument goes, there are undeniable benefits and improvements. After all, almost all of us are Facebook friends, aren't we?

But maybe Richard Sennett is right when he notes that our postmodern anti-urbanism and hostility towards games have not only made us tribal, childlike and rural, but have also made our culture 'more primitive [. . .] than the simplest tribe of hunters and gatherers' (Sennett 1978: 15). Tribal communities can never be as rural and witless as we are. While we, Sennett argues, have moved 'from something like an other-directed condition to an inner-directed condition' (Sennett 1978: 5) and now indulge in a tyranny of intimacy (Sennett 1978: 18), tribal cultures can be seen as prime examples of other-directed cultures. For example, those of them who eat taboo food die as if poisoned. What is important here is not internal, subjective intentions, but only external, objective appearances; what a virtual naive observer might have perceived – for example, that the hungry person eating from the chief's food wanted to insult the chief. Furthermore, taboo societies tend to use formal forms of address (instead of saying 'you', they say, for example 'sister' or 'brother'), and are discreet in using first names (see Freud [1912–13]: 303, 306, 347).

Despite all the implosions, it should not be necessary in the global village that everything depends on intentions, or that politicians are only judged by their private lives. There is no need for us to call everybody by their first names as children do, and there is no need to be afraid of all the challenges of civilised life as children are, and to call for a prohibiting authority. We should

follow the example of the so-called savages. Perhaps primitiv-
ism, which has found its way into modern Western art since
the beginning of the twentieth century, could be understood
in this sense: not only as an effect of retribalisation, but rather
as an attempt to remind a culture that is developing towards
anti-urbanism of the humour of the supposed primitives. This is
exactly what Johan Huizinga refers to when he lucidly states that
'the mental attitude in which the great religious feasts of savages
are celebrated and witnessed is not one of complete illusion:
There is an underlying consciousness of things "not being real"'
(Huizinga 1950: 22).

The modern equivalent of the ancient virtue of urbanity
is not the essentialisation of and contempt for the supposedly
naive others, but respect for those who operate with suspended
illusions and take pleasure in them, without accusing anyone of
naivety. The supposed savages could teach us, for instance, to
cultivate such 'an underlying consciousness of things "not being
real"' – which means expecting it from others and enduring it
in ourselves.

Note

1 Cicero 1986: 50–1, 128–9, 352–3, 358–9, 470–3.
2 Quintilian 1988: 721; see Federhofer 2001: 12.
3 Castiglione 1996; cf. Roodenburg 1999: 122. As to Castiglione's rare use
 of the term, see Kramer 2010: 236.
4 See Lange 1968: 143. Pellegrini and Gracián refer to these as *acutezze*
 and *argutezze*, respectively (see Lange 1968: 14–15). Following a similar
 line of thought, Aaron Gurjewitsch argues that it is no coincidence that
 the medieval tradition of carnival did not emerge before the end of the
 thirteenth century and the beginning of the fourteenth century: carnival
 is a great festival of the fully established medieval town with a new type of

population, which was concentrated on a territory and developed into a new form of medieval culture (Gurjewitsch 1999: 59).

5 For Tesauro's use of this contrastive pair, see Lange 1968: 33.

6 Quintilian 1988: 756 (IV 3, 107); see Federhofer 2001: 11.

7 This view, rarely to be found in contemporary aesthetics, is still present in the discourse on football where brutal play is often referred to as 'agricultural'.

8 See Le Goff 1999: 56; he also notes that for various interesting reasons people can better laugh in the vernacular than in Latin (46).

9 This can be rendered roughly, albeit without the transitions between dialect and literary language, as follows: 'And with elasticity that goes by itself, Ferdinand drags Mitzi to the dancefloor' (my translation).

10 Tesauro lists the following categories of people who are able to speak *argut*: first, there are those who have the faculty of 'ingegno naturale' and second those seized by 'frenzy' (*furore*) – by wrought-up passions (*passioni*); these are separated by Tesauro into divine inspiration (*afflato*) and madness (*pazzia*). Finally, *argut* can also arise through the exercise (*esercitio*) of certain techniques (see Lange 1968: 32–5). Tesauro also gives a lucid account of the drawbacks and vexations related to the divine *ingegno*, as compared to the more good-natured *prudenza* (Lange 1968: 33–4). This gives an indication of the 'impure', 'dirty' dimension of the holy in culture (see Pfaller 2008).

11 'I adore simple pleasures. They are the last refuge of the complex.' Wilde 1997: 549.

12 For this understanding of the Freudian concept of sublimation, see Pfaller 2009.

13 Cicero 1986: 158–9.

14 Cicero 1986: 50–1.

15 See Alain: 'Polite behavior can strongly influence our thoughts. And miming graciousness, kindness, and happiness is of considerable help in combating ill humor and even stomach aches; the movements involved – gracious gestures and smiles – do this much good; they exclude the possibility of the contrary movements, which express rage, defiance, and sadness. That is why social activities, visits, formal occasions, and parties are so well liked. It is a chance to imitate happiness; and this kind of comedy certainly frees us from tragedy – no small accomplishment' (Alain 1973: 44–5).

16 As to the conceptual pair 'mechanical/organic solidarity', see Durkheim 1988: 230, 108. Cf. Kraxberger 2010.

17 The only reason for Kant to consider politeness also morally permissible is 'because it is understood by everyone that nothing is meant sincerely by this' (Kant 1978a: 442; 1996: 39).

18 For an account of the theory of the 'naive observer', see Pfaller 2014: 231–83.

19 See Pascal 1995: 120. For a reading of the aesthetics of 'that certain something', see Ullrich 2005: 9–30.

20 See Hughes 1993; for the 'theft of enjoyment', see Žižek 1993: 203.

21 See McLuhan 1987. For McLuhan's compelling thesis about cultural shifts, according to which hot cultures require cold games and cold cultures require hot games, see Pfaller 2008: 99–103.

22 See Freud [1927b]; cf. also Freud [1905a]: 219: 'For the euphoria which we endeavour to reach by these means is nothing other than the mood of a period of life in which we were accustomed to deal with our psychical work in general with a small expenditure of energy – the mood of our childhood, when we were ignorant of the comic, when we were incapable of jokes and when we had no need of humour to make us feel happy in our life' (Freud [1905a]: 236).

Bibliography

Adams, Douglas (1997), *Dirk Gently's Holistic Detective Agency*, New York: pocket books.

Adorno, Theodor W. (1977), *Vorschlag zur Ungüte*, in *Gesammelte Schriften*, vol. 10.1, Frankfurt.

Adorno, Theodor W. (1982 [1966]), *Negative Dialektik*, 3rd edn, Frankfurt am Main: Suhrkamp.

Agamben, Giorgio (2005), *Profanierungen*, Frankfurt am Main: Suhrkamp.

Agamben, Giorgio (2007), 'Genius', in Giorgio Agamben, *Profanations*, trans. Jeff Fort, New York: Zone Books.

Alain (1973), *On Happiness*, New York: Frederick Ungar.

Allais, Alphonse (2007), 'Un drame bien parisien', in *Trois nouvelles comiques. Alphonse Allais, Marcel Aymé, Eugène Ionesco*, Paris: Gallimard.

Althusser, Louis (1971), 'Ideology and Ideological State Apparatuses', in Louis Althusser, *Lenin and Philosophy and Other Essays*, New York: Monthly Review Press, 127–86.

Althusser, Louis (1990), *Philosophy and the Spontaneous Philosophy of the Scientists & Other Essays*, London: Verso.

Althusser, Louis (1993), *Écrits sur la psychanalyse*, Paris: Stock/IMEC.

Althusser, Louis (1994), *L'avenir dure longtemps, suivi de Les Faits*, new edn, Paris: Stock/IMEC.

Althusser, Louis (2006 [1968]), 'From *Capital* to Marx's Philosophy', in Louis Althusser and Étienne Balibar, *Reading Capital*, trans. Ben Brewster, London: Verso, 11–70.

Anders, Günther (1988), *Die Antiquiertheit des Menschen*, 2 vols, Munich: Beck.

Aristotle (1996), *Poetics*, London: Penguin.

Bachelard, Gaston (1974), *Epistemologie. Ausgewählte Texte*, ed. D. Lecourt, Frankfurt am Main: Ullstein.

139

Balibar, Étienne (1991), *Écrits pour Althusser*, Paris: Éditions la Découverte.

Barthes, Roland (1982 [1970]), *Empire of Signs*, trans. Richard Howard, New York: Hill and Wang.

Barthes, Roland (1989 [1980]), *Sade, Fourier, Loyola*, trans. Richard Miller, Berkeley: University of California Press.

Barthes, Roland (2007 [1975]), *Über mich selbst*, Berlin: Matthes & Seitz.

Barthes, Roland (2013 [1957]), *Mythologies: The Complete Edition, in a New Translation*, New York: Hill and Wang.

Bataille, Georges (1955), *Lascaux; or The Birth of Art: Prehistoric Painting*, Lausanne: Skira.

Bataille, Georges (1986), *Eroticism: Death and Sexuality*, San Francisco: City Lights Books.

Bernays, Jacob (1979), 'Aristotle on the Effect of Tragedy', in J. Barnes, M. Schofield and R. Sorabji (eds), *Articles on Aristotle, 4. Psychology and Aesthetics*, London: Duckworth, 154–65.

Bloom, Harold (2000), 'Bloom Extols Pleasures of Solitary Reading', *Yale Bulletin & Calendar*, 29.1, http://www.yale.edu/opa/v29.n1/story4.html.

Bozovic, Miran (2000), *An Utterly Dark Spot. Gaze and Body in Early Modern Philosophy*, Ann Arbor: University of Michigan Press.

Brecht, Bertold (1971), *Über Politik auf dem Theater*, ed. W. Hecht, Frankfurt am Main: Suhrkamp.

Bremmer, Jan, and Roodenburg, Herman (eds) (1999), *Kulturgeschichte des Humors. Von der Antike bis heute*, Darmstadt: Wiss. Buchges.

Brock, Bazon (2008), *Lustmarsch durch das Theoriegelände – Musealisiert Euch*, Cologne: Dumont.

Butler, Judith (1995), 'Conscience Doth Make Subjects of Us All', *Yale French Studies*, 88: 6–26, special issue, *Althusser, Balibar, Macherey and the Labor of Reading*.

Castiglione, Baldessare (1996 [1528]), *Der Hofmann. Lebensart in der Renaissance*, Berlin: Wagenbach.

Cicero (1855–1893), *Brutus oder Von den berühmten Rednern*, in *Langenscheidtsche Bibliothek sämtlicher griechischen und römischen Klassiker, 86. Bd.: Cicero. IX*, Berlin and Stuttgart: Langenscheidt.

Cicero (1986), *De oratore. Über den Redner. Lat. u. deutsch*, Stuttgart: Reclam.

Cicero (2004), *Orator. Der Redner. Lat. u. deutsch*, Stuttgart: Reclam.

Clemens, Justin (2005), 'The Politics of Style in the Works of Slavoj Žižek', in Geoff Boucher, Jason Glynos and Matthew Sharpe (eds), *Traversing the Fantasy. Critical Responses to Slavoj Žižek*, Aldershot: Ashgate, 3–22.

Culler, Jonathan (1983), *On Deconstruction: Theory and Criticism after Structuralism*, London: Routledge.

Daniels, Dieter (2003), 'Strategien der Interaktivität', http://www.hgb-leipzig.de/daniels/vom-readymade-zum-cyberspace/strategien_der_interaktivitaet.html (last accessed 12 November 2006).

David, C. (1997), 'Preface', in *A Short Guide to documenta X*, Ostfildern: Cantz, 6–13.

Dean, Tim (2002), 'Art as Symptom: Žižek and the Ethics of Psychoanalytic Criticism', *Diacritics*, 32.2: 21–41.

Deleuze, Gilles, and Guattari, Félix (2000 [1983]), *Anti-Oedipus. Capitalism and Schizophrenia*, Minneapolis: University of Minnesota Press.

Deleuze, Gilles, and Parnet, Claude (1996), *Dialogues*, Paris: Flammarion.

Derrida, Jacques (1987), *The Truth in Painting*, trans. Geoffrey Bennington and Ian McLeod, Chicago: University of Chicago Press.

Descartes, René (1949), *Briefe 1629–1650*, ed. Max Bense, Cologne and Krefeld: Staufen.

Dolar, Mladen (2001), 'The Enjoying Machine', *Umbra*: 123–40, http://www.umbrajournal.org/pdfs/Umbra-Polemos-2001.pdf (last accessed 8 November 2016).

Durkheim, Émile (1988), *Über soziale Arbeitsteilung: Studie über die Organisation höherer Gesellschaften*, Frankfurt am Main: Suhrkamp.

Eco, Umberto (1987), *Lector in fabula. Die Mitarbeit der Interpretation in erzählenden Texten*, Munich and Vienna: Hanser.

Eco, Umberto (1989), *The Open Work*, trans. Anna Cancogni, Cambridge, MA: Harvard University Press.

Enwezor, Okwui (2002), interview in *Kunstforum*, 161, August: 82–91.

Exner, L. (1997), 'Wo das Wort Schrulle wird', *Die Presse, spectrum*, 16.8: iv.

Federhofer, Marie-Theres (2001), '"Urbanitas" als Witz und Weltläufigkeit. Zur Resonanz einer rhetorischen Kategorie im 17. und 18. Jahrhundert', *Nordlit*, 9: 3–27, http://www.hum.uit.no/nordlit/9/1Federhofer.html Zugriff (last accessed 19 March 2012).

Feustel, Robert, Koppo, Nico, and Schölzel, Hagen (eds) (2011), *Wir sind nie aktiv gewesen. Interpassivität zwischen Kunst- und Gesellschaftskritik*, Berlin: Kulturverlag Kadmos.

Fischer-Lichte, Erika (2004), *Ästhetik des Performativen*, Frankfurt am Main: Suhrkamp.

Franck, Georg (1998), *Ökonomie der Aufmerksamkeit – Ein Entwurf*, Munich: Hanser.

Freud, Sigmund [1900], *The Interpretation of Dreams*, in Freud (1953–74), vols 4–5.

Freud, Sigmund [1905a], *Jokes and their Relation to the Unconscious*, in Freud (1953–74), vol. 8.

Freud, Sigmund [1905b], *Three Essays on the Theory of Sexuality*, in Freud (1953–74), vol. 7: 125–245.

Freud, Sigmund [1907], 'Obsessive Actions and Religious Practices', in Freud (1953–74), vol. 9: 115–27.

Freud, Sigmund [1908]. '"Civilized" Sexual Morality and Modern Nervous Illness', in Freud (1953–74), vol. 9: 179–204.

Freud, Sigmund [1909], *Notes upon a Case of Obsessional Neurosis*, in Freud (1953–74), vol. 10: 153–249.

Freud, Sigmund [1912–13], *Totem and Taboo*, in Freud (1953–74), vol. 13: 1–161.

Freud, Sigmund [1914], 'On Narcissism: An Introduction', in Freud (1953–74), vol. 14: 67–102.

Freud, Sigmund [1919], 'The Uncanny', in Freud (1953–74), vol. 17: 219–56.

Freud, Sigmund [1920], 'Beyond the Pleasure Principle', in Freud (1953–74), vol. 18: 7–64.

Freud, Sigmund [1921], 'Group Psychology and the Analysis of the Ego', in Freud (1953–74), vol. 18: 67–143.

Freud, Sigmund [1924], 'The Economic Problem of Masochism', in Freud (1953–74), vol. 19: 157–70.

Freud, Sigmund [1927a], 'Fetishism', in Freud (1953–74), vol. 21: 147–57.

Freud, Sigmund [1927b], 'Humour', in Freud (1953–74), vol. 21: 161–8.

Freud, Sigmund [1928], 'Dostoevsky and Parricide', in Freud (1953–74), vol. 21: 173–94.

Freud, Sigmund [1930], 'Civilization and its Discontents', in Freud (1953–74), vol. 21: 59–145.

Freud, Sigmund [1940a], 'An Outline of Psycho-Analysis', in Freud (1953–74), vol. 23: 144–207.

Freud, Sigmund [1940b], 'Splitting of the Ego in the Process of Defence', in Freud (1953–74), vol. 23: 271–8.

Freud, Sigmund (1953–74), *The Standard Edition of the Complete Psychological Works of Sigmund Freud*, 24 volumes, ed. James Strachey et al., London: The Hogarth Press.

Geier, Manfred (2002), *Die kleinen Dinge der großen Philosophen*, Munich and Zurich: Piper.

Grunberger, Béla, and Dessuant, Pierre (1997), *Narcissisme, christianisme, anti-sémitisme. Étude psychanalytique*, Arles and Paris: Actes Sud.

Gurjewitsch, Aaron (1999), 'Bachtin und seine Theorie des Karnevals', in Bremmer and Roodenburg (eds): 109–26.

Hardt, Michael, and Negri, Antonio (2000), *Empire*, Cambridge, MA: Harvard University Press.

Heinrich, Klaus (1997), *Anfangen mit Freud*, Basel and Frankfurt am Main: Stroemfeld (Roter Stern).

Hiebaum, Christian (2008), *Bekenntnis und Interesse. Essay über den Ernst in der Politik*, Berlin: De Gruyter.

Hossenfelder, Malte (1996), *Antike Glückslehren. Kynismus und Kyrenaismus, Stoa, Epikureismus und Skepsis. Quellen in deutscher Übersetzung mit Einführungen*, Stuttgart: Kröner.

Hughes, Robert (1993), *Culture of Complaint: The Fraying of America*, New York: Oxford University Press.

Huizinga, Johan (1950), *Homo Ludens. A Study of the Play Element in Culture*, Boston: Beacon Press.

Hume, David (1907 [1779]), *Dialogues Concerning Natural Religion*, Edinburgh: W. Blackwood.

Humphrey, Caroline, and Laidlaw, James (1994), *The Archetypal Actions of Ritual. A Theory of Ritual Illustrated by the Jain Rite of Worship*, Oxford: Clarendon Press.

Iser, Wolfgang (1972), *Der implizite Leser*, Munich: Fink.

Johnsen, Rasmus, Muhr, Sara Louise, and Pedersen, Michael (2009), 'The Frantic Gesture of Interpassivity: Maintaining the Separation between the Corporate and the Authentic Self', *Journal of Organizational Change Management*, 22.2: 202–13.

Kant, Immanuel (1965 [1781/1787]), *Critique of Pure Reason*, trans. Norman Kemp Smith, New York: St. Martin's Press.

Kant, Immanuel (1974 [1785]), *Grundlegung zur Metaphysik der Sitten*, in Immanuel Kant, *Werkausgabe*, vol. VII, Frankfurt am Main: Suhrkamp, 7–102.

Kant, Immanuel (1977a [1784]), 'Beantwortung der Frage: "Was ist Aufklärung?"', in Immanuel Kant, *Werkausgabe*, vol. XI, Frankfurt am Main: Suhrkamp, 53–61.

Kant, Immanuel (1977b [1763]), *Versuch den Begriff der negativen Grössen in die Weltweisheit einzuführen*, in Immanuel Kant, *Werkausgabe*, vol. II, Frankfurt am Main, 779–820.

Kant, Immanuel (1978a [1798]), *Anthropologie in pragmatischer Hinsicht*, in Immanuel Kant, *Werkausgabe*, vol. XII, Frankfurt am Main: Suhrkamp, 399–690.

Kant, Immanuel (1978b [1797]), *Metaphysik der Sitten*, in Immanuel Kant, *Werkausgabe*, vol. VIII, 2nd edn, Frankfurt am Main: Suhrkamp.

Kant, Immanuel (1996), *Anthropology from a Pragmatic Point of View*, Carbondale and Edwardsville: Southern Illinois University Press.

Kant, Immanuel (2002 [1788]), *Critique of Practical Reason*, trans. Werner S. Pluhar, Indianapolis: Hackett.

Kant, Immanuel (2007), *Critique of Judgment*, New York: Cosimo.

Kant, Immanuel (2008 [1790]), *Critique of the Power of Judgment*, ed. Paul Guyer and Eric Matthews, Cambridge: Cambridge University Press.

Kant, Immanuel (2010 [1784]), *An Answer to the Question: 'What Is Enlightenment?'*, New York: Penguin.

Kemp, Wolfgang (ed.) (1992), *Der Betrachter ist im Bild. Kunstwissenschaft und Rezeptionsästhetik*, Berlin and Hamburg: Reimer.

Klossowski, Pierre (1989 [1965]), *Les Lois de l'hospitalité*, Mayenne: Gallimard.

Kramer, Olaf (2010), *Goethe und die Rhetorik*, Berlin: de Gruyter.

Kraxberger, Sabine (2010), 'Solidaritätskonzepte in der Soziologie', http://momentum-kongress.org/cms/uploads/documents/Beitrag_Kraxberger8_3_2011_5523.pdf (last accessed 8 November 2016).

Krips, Henry (1999), *Fetish. An Erotics of Culture*, Ithaca: Cornell University Press.

Kross, Matthias (1999), 'Philosophieren in Beispielen. Wittgensteins Umdenken des Allgemeinen', http://www.momo-berlin.de/Kross_Wittgenstein.html (last accessed 18 April 2006).

Kuldova, Tereza (2013), 'Designing Interpassive Indianness: The Work of Aesthetics in Intimate Encounters with Nation at a Distance', https://www.academia.edu/5439863/Designing_Interpassive_Indianness_The_Work_of_Aesthetics_in_Intimate_Encounters_with_Nation_at_a_Distance (last accessed 21 October 2013).

Kuldova, Tereza (2016), *Luxury Indian Fashion. A Social Critique*, London: Bloomsbury.

Lacan, Jacques (1986), *Le Séminaire VII – L'éthique de la psychanalyse*, Paris: Seuil.

Lafargue, Paul (1883), 'The Right to be Lazy', http://www.marxists.org/archive/lafargue/1883/lazy/index.htm (last accessed 19 June 2014).

Lange, Klaus-Peter (1968), *Theoretiker des literarischen Manierismus. Tesauros und Pellegrinis Lehre von der 'Acutezza' oder von der Macht der Sprache*, Munich: Fink.

Lazzarato, Maurizio (1998), 'Immaterielle Arbeit. Gesellschaftliche Tätigkeit unter den Bedingungen des Postfordismus', in T. Negri et al., *Umherschweifende Produzenten. Immaterielle Arbeit und Subversion*, Berlin: ID-Verlag, 39–52.

Le Goff, Jacques (1999), 'Lachen im Mittelalter', in Bremmer and Roodenburg (eds): 109–27.

Lehmann, Ulrike, and Weibel, Peter (eds) (1994), *Ästhetik der Absenz. Bilder zwischen Anwesenheit und Abwesenheit*, Munich: Klinkhardt & Biermann.

Leiris, Michel (2016 [1938]), *Le sacré dans la vie quotidienne; suivi de Notes pour 'Le sacré dans la vie quotidienne ou L'homme sans honneur'*, Paris: Éditions Allia, 2016.

Lyotard, J.-F. (1989), 'The Sublime and the Avant-Garde', in *The Lyotard Reader*, ed. A. Benjamin, Oxford: Blackwell, 196–211.

McLuhan, Marshall (1987 [1964]), *Understanding Media. The Extensions of Man*, London: Routledge.

McLuhan, Marshall (2001), *Das Medium ist die Botschaft*, Dresden: Philo Fine Arts.

Malevich, Kasimir (1980), *Die gegenstandslose Welt*, Mainz and Berlin: Kupferberg.

Mannoni, Octave (1985a), *Clefs pour l'imaginaire ou l'autre scène*, Paris: Seuil.

Mannoni, Octave (1985b), 'La desidentification', in J. Dor (ed.), *Le Moi et l'autre*, Paris: Denoël, 61–79.

Mannoni, Octave (2003), 'I Know Well, But All the Same . . .', in M. A. Rothenberg and D. Foster (eds), *Perversion and the Social Relation*, Durham, NC: Duke University Press, 68–92.

Maruschi, Luiz Antonio (1976), *Die Methode des Beispiels. Untersuchungen über die methodische Funktion des Beispiels in der Philosophie, insbesondere bei Ludwig Wittgenstein*, Erlangen: Palm & Enke.

Mauss, Marcel (2002 [1923]), *The Gift: The Form and Reason for Exchange in Archaic Societies*, trans. W. D. Halls, London: Routledge.

Mulvey, Laura (1986 [1984]), 'Visual Pleasure and Narrative Cinema', in Brian Wallis (ed.), *Art after Modernism. Rethinking Representation*, New York: New Museum of Contemporary Art, 361–74.

Münkler, Herfried (2011), 'Der erste Politiker. Interview', *Hohe Luft Philosophie-Magazin*, 1: 48–52.

Nietzsche, Friedrich (1910 [1887]), *The Genealogy of Morals, A Polemic*, trans. H. B. Samuel, in Friedrich Nietzsche, *The Complete Works*, ed. Oscar Levy, vol. 13, Edinburgh and London: T. N. Foulis.

Nietzsche, Friedrich (1984 [1887]), *Zur Genealogie der Moral*, in Friedrich Nietzsche, *Werke*, vol. III, ed. K. Schlechta, Frankfurt am Main: Ullstein, 207–384.

Nietzsche, Friedrich (2007 [1887]), *On the Genealogy of Morality*, ed. K. Ansell-Pearson, trans. C. Diethe, Cambridge: Cambridge University Press.

Pascal, Blaise (1965 [1669]), *Pensées*, ed. Jacques Chevalier, Paris: Livre de Poche.

Pascal, Blaise (1995 [1669]), *Pensées*, trans. A. J. Krailsheimer, London: Penguin.

Perniola, Mario (1998), *Transiti. Filosofia e perversione*, Rome: Castelvecchi.

Perniola, Mario (1999), *Der Sex-Appeal des Anorganischen*, Vienna: Turia + Kant.

Pfaller, Robert (1992), 'Verkennen, Erkennen. Die Psychoanalyse als Instrument einer Theorie der Erkenntnis bei Gaston Bachelard und Louis Althusser', *Mesotes*, 1: 27–35.

Pfaller, Robert (1996), 'Um die Ecke gelacht. Kuratoren nehmen uns die Kunstbetrachtung ab, Videorecorder schauen sich unsere Lieblingsfilme an: Anmerkungen zum Paradoxon der Interpassivität', *Falter*, 41.96: 71.

Pfaller, Robert (1997a), *Althusser. Das Schweigen im Text*, Munich: Fink.

Pfaller, Robert (1997b), 'Philosophy and the Spontaneous Philosophy of the Artists', in H. Lachmayer, Chr. Möller and M. Knipp (eds), *Archimedia, Institute for Arts and Technology: Projekte 95/97*, Linz, 170–82.

Pfaller, Robert (1998), 'The Work of Art that Observes Itself. Eleven Steps Towards an Aesthetics of Interpassivity', in Centro de studiis por la scultura publica ambiental (ed.), *Presencias en el espacio publico contemporaneo*, Barcelona, 229–40, http://scholar.googleusercontent.com/scholar?q=cach e:iurQusdH3egJ:scholar.google.com/+pfaller+work+of+art+observes+its elf&hl=de&as_sdt=0,5 (last accessed 8 November 2016).

Pfaller, Robert (ed.) (2000), *Interpassivität. Studien über delegiertes Genießen*, Vienna and New York: Springer.

Pfaller, Robert (2003), 'Little Gestures of Disappearance. Interpassivity and the Theory of Ritual', *Journal of European Psychoanalysis, Humanities, Philosophy, Psychotherapies*, 16: 3–16, http://www.psychomedia.it/jep/number16/ pfaller.htm (last accessed 2 January 2017).

Pfaller, Robert (2008), *Ästhetik der Interpassivität*, Hamburg: philo fine arts.

Pfaller, Robert (2009), 'Sublimation and "Schweinerei". Theoretical Place and Cultural-critical Function of a Psychoanalytic Concept', *Journal of European Psychoanalysis*, 29: 11–47, http://www.psychomedia.it/jep/number29/ pfaller.htm (last accessed 21 December 2016).

Pfaller, Robert (2012), *Zweite Welten. Und andere Lebenselixiere*, Frankfurt am Main: Fischer.

Pfaller, Robert (2014), *The Pleasure Principle in Culture. Illusions without Owners*, London: Verso.

Pontalis, Jean-Bertrand (ed.) (1970), 'Objets du fétichisme', *Nouvelle Revue de Psychanalyse*, 2.

Pontalis, Jean-Bertrand (ed.) (1972), *Objekte des Fetischismus*, Frankfurt am Main: Suhrkamp.

Qualtinger, Helmut (1995), *'Der Herr Karl' und andere Texte fürs Theater*, Vienna: Deuticke.

Quintilian (1948), *Institutio oratoria*, trans. H. E. Butler, Cambridge, MA: Harvard University Press/London: Heinemann.

Quintilian (1988), *Ausbildung des Redners*, ed. Zwölf Reden, trans. H. Rahn, vol. I, 2nd edn, Darmstadt: Wiss. Buchges.

Ramage, Edwin S. (1973), *Urbanitas. Ancient Sophistication and Refinement*, Norman: University of Oklahoma Press.

Reich, Wilhelm (1995 [1932]), *Der Einbruch der sexuellen Zwangsmoral*, Cologne: Kiepenheuer & Witsch.

Rifkin, Jeremy (2001), *The Age of Access: The New Culture of Hypercapitalism, Where All of Life Is a Paid-for Experience*, New York: Tarcher/Putnam.

Roodenburg, Herman (1999), '"Um angenehm unter den Menschen zu verkehren": Die Etikette und die Kunst des Scherzens im Holland des 17. Jahrhunderts', in Bremmer and Roodenburg (eds): 109–26.

Sade, Donatien Alphonse François, Marquis de (2008 [1785]), *The 120 Days of Sodom*, Radford, VA: Wilder Publications.

Saussure, Ferdinand de (1987 [1916]), *Cours de linguistique générale*, Paris: Payot.

Schiller, Friedrich (2005 [1793]), 'Über Anmut und Würde', in Friedrich Schiller, *Sämtliche Werke*, vol. VIII: *Philosophische Schriften*, Berlin: Aufbau, 168–204.

Sennett, Richard (1978 [1974]), *The Fall of Public Man*, New York: Vintage.

Slouka, Mark (1995), *War of the Worlds. Cyberspace and the High-Tech Assault on Reality*, New York: Basic Books.

Sontag, Susan (2001a [1964]), 'Against Interpretation', in Susan Sontag, *Against Interpretation and Other Essays*, New York: Picador, 3–14.

Sontag, Susan (2001b [1964]), 'Notes on "Camp"', in Susan Sontag, *Against Interpretation and Other Essays*, New York: Picador, 275–92.

Spinoza, Benedict de (1955 [1662, 1677]), *On the Improvement of the Understanding. The Ethics. Correspondence*, trans. R. H. M. Elwes, New York: Dover.

Spinoza, Benedict de (1967 [1670]), *Der Theologisch-politische Traktat*, Leipzig: Reclam.

Stepken, Angelika (1998), 'Künstler fährt Auto zu Schrott. Ökologische Dienstleistung: Ronald Eckelt bietet Auto-Crashs an', *Zitty* 9: 54.

Ullrich, Wolfgang (2003), *Tiefer hängen. Über den Umgang mit Kunst*, 2nd edn, Berlin: Wagenbach.

Ullrich, Wolfgang (2005), *Was war Kunst? Biographien eines Begriffs*, Frankfurt am Main: Fischer.

van Oenen, Gijs (2006), 'A Machine that Would Go of Itself: Interpassivity and its Impact on Political Life', *Theory & Event*, 9.2, https://muse.jhu. edu/login?auth=0&type=summary&url=/journals/theory_and_event/ v009/9.2vanoenen.html (last accessed 31 July 2014).

van Oenen, Gijs (2010), 'Three Cultural Turns: How Multiculturalism, Interactivity and Interpassivity Affect Citizenship', *Citizenship Studies*, 14.3: 293–306.

Vattimo, Gianni (1991), *The End of Modernity: Nihilism and Hermeneutics in Postmodern Culture*, Baltimore: Johns Hopkins University Press.

Virilio, Paul (1980), *Esthétique de la disparition*, Paris: Balland.

Wagner, Silvan (ed.) (2015), *Interpassives Mittelalter? Interpassivität in mediävistischer Diskussion*, Frankfurt am Main: Peter Lang.

Weber, Max (2002 [1905]), *The Protestant Ethic and the 'Spirit' of Capitalism. And Other Writings*, New York: Penguin.

Weibel, Peter (1999), 'Kunst als offenes Handlungsfeld', in P. Weibel (ed.), *Offene Handlungsfelder*, Cologne: DuMont, 8–21.

Wilde, Oscar (1997 [1893]), *A Woman of No Importance*, in *Collected Works of Oscar Wilde. The Plays, the Poems, the Stories and the Essays including De Profundis*, Ware: Wordsworth Editions, 533–88.

Wittgenstein, Ludwig (1967 [1953]), *Philosophical Investigations*, trans. G. E. M. Anscombe, 2nd edn, Oxford: Blackwell.

Wittgenstein, Ludwig (1975), *Philosophical Remarks*, Oxford: Blackwell.

Wittgenstein, Ludwig (1979 [1931]), *Remarks on Frazer's 'Golden Bough'*, Retford: The Brynmill Press.

Wittgenstein, Ludwig (1981), *Philosophische Bemerkungen*, Frankfurt am Main: Suhrkamp.

Wittgenstein, Ludwig (1993a [1931]), 'Remarks on Frazer's *Golden Bough*', in Wittgenstein (1993b), 119–55.

Wittgenstein, Ludwig (1993b), *Philosophical Occasions 1912–1951*, ed. J. C. Klagge and A. Nordmann, Indianapolis: Hackett.

Yoshida, Miya (2008), 'Interactivity, Interpassivity and Possibilities Beyond Dichotomy', in Frank Eckhardt (ed.), *Mediacity: Situations, Practices, Encounters*, Berlin: Frank & Timme, 57–79.

Žerovc, Beti (2012), 'Why is it Important in the Art Field to Think about Art Events?', *maska*, XXVII.147–8: 16–21.

Žižek, Slavoj (1991), *For They Know Not What They Do. Enjoyment as a Political Factor*, London: Verso.

Žižek, Slavoj (1993), *Tarrying with the Negative. Kant, Hegel and the Critique of Ideology*, Durham, NC: Duke University Press.

Žižek, Slavoj (1997 [1989]), *The Sublime Object of Ideology*, London: Verso.

Žižek, Slavoj (1998), 'The Interpassive Subject', http://www.egs.edu/faculty/slavoj-zizek/articles/the-interpassive-subject/ (accessed 1 April 2011).

Žižek, Slavoj (1999), 'Introduction: The Spectre of Ideology', in Slavoj Žižek (ed.), *Mapping Ideology*, London: Verso, 1–33.

Žižek, Slavoj (2002a), 'Kulturkapitalismus', in Slavoj Žižek, *Die Revolution steht bevor. Dreizehn Versuche über Lenin*, Frankfurt am Main: Suhrkamp, 117–26.

Žižek, Slavoj (2002b), 'Multiculturalism, Or, the Cultural Logic of Multinational Capitalism', http://www.ata.boun.edu.tr/htr/documents/312_10/Zizek,%20Slavoj_%20Multiculturalism%20or%20the%20Cultural%20Logic%20of%20Capitalism.pdf (last accessed 8 November 2016).

Žižek, Slavoj (2004), 'Will You Laugh for Me, Please', http://www.lacan.com/zizeklaugh.htm (last accessed 16 April 2006).

Žižek, Slavoj (2004), 'Passion in the Era of Decaffeinated Belief', http://www.lacan.com/passion.htm (last accessed 8 November 2016).

Žižek, Slavoj (2014), *Žižek's Jokes (Did you hear the one about Hegel and negation?)*, Cambridge, MA: MIT Press.

Index

Printed and bound by CPI Group (UK) Ltd, Croydon, CR0 4YY

10/12/2024

01803326-0001